RONALD RUSSELL

Discovering
Antique Prints

SHIRE PUBLICATIONS LTD

Contents

ACKNOWLEDGEMENTS

The cover illustration is a detail from Llyn Ogween, an aquatint after P.J. De Loutherbourg by William Pickett, colouring by John Clarke, from 'The Romantic and Picturesque Scenery of England and Wales', 1805.

Figures 3 and 4 are reproduced by permission of Messrs David and Charles.

Set in 9 on 9 point Times by Permanent Typesetting and Printing Co Ltd, Hong Kong, and printed in Great Britain by C. I. Thomas & Sons (Haverfordwest) Ltd.

Introduction

Prints are popular and easy to collect yet little is generally known about them. In this book I hope to provide some information which you will find helpful both in identifying prints and in understanding something of their history. It is intended as a guide to the contents of a well stocked print shop but I am well aware that it is not comprehensive. The subject is so vast – after all, it comprises all pictorial reproduction in the centuries between the invention of printing and the development of photography – that careful selection is necessary for any book about it, let alone this little one.

This book, then, discusses only British prints by British printmakers. It is not concerned with 'old master' prints but concentrates on items that, for the most part, are readily collectable; you will not have to sell your house, or even your car, to buy anything referred to in these pages. The term *antique* can be taken to mean over a hundred years old, and that is the limit I have chosen. For several centuries prints were used as book illustrations, and this complicates matters still further. I have not tried to follow a hard and fast rule about this but I have omitted the illustrative work of William Blake and any consideration of the Victorian woodblock illustrators. Otherwise, I hope you will find what you are looking for, both in the pages which follow and in the shops of the printsellers, where perhaps you will be encouraged to go.

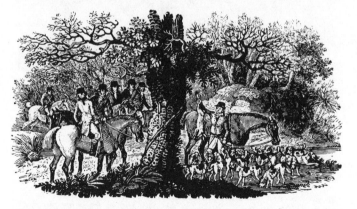

Fig. 1. Wood engraving by Thomas Bewick, illustrating William Somerville's poem 'The Chace'. This is one of Bewick's most elaborate cuts and one of the very few showing a hunting scene. According to Dr Johnson, 'to this poem praise cannot be totally denied'.

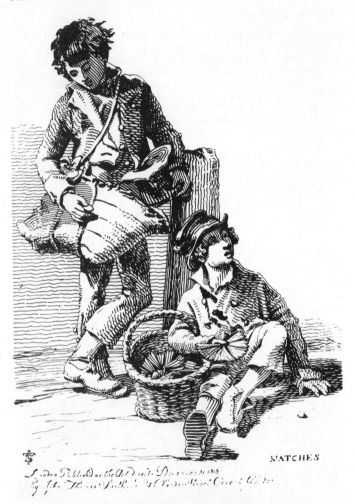

MATCHES

Fig. 2. 'Matches', an etching by John Thomas Smith and published by him in 1815. 'Antiquity' Smith, as he was known from his principal interest, etched a number of portraits of London beggars and street traders from the life, publishing them in 'Vagabondiana', 1817. Smith portrayed the lad on the right two years after this drawing: he was then a crossing sweeper at Princes Street, Hanover Square.

1. Where do prints come from?

Prints can be bought from specialist print dealers, antiquarian booksellers, auction rooms, antique dealers and some art galleries. (A list of specialist dealers appears on pages 86-7 of this book.) They may be framed or unframed, mounted ready for framing, black and white, modern hand-coloured, originally coloured or sepia toned, and sometimes they come with accompanying letterpress. They will have been produced by one of a large number of different methods and you will not always find that the seller is certain or accurate about which. It is helpful if you can 'read' the print yourself and it makes prints more interesting if you know how they originated and were marketed when they were new.

The prints you buy today were originally published as single sheets, in parts or in books (often made up of a collected set of parts). Some were made or commissioned by painters to widen the knowledge of their work by providing cheap reproductions; Sir David Wilkie made more money from selling the engraving rights of his pictures than he did from selling the pictures themselves. Some were instigated by publishers or dealers: Turner's *Picturesque Views in England and Wales* was devised by the publisher-engraver Charles Heath and the printsellers Jennings and Company. Some told a story with a moral: Hogarth's *Marriage à la Mode* or Cruikshank's *The Bottle*, for example. Political and patriotic feelings inspired the caricatures of Gillray and Rowlandson and the sheer love of the craft itself moved Samuel Palmer to recapture in his etchings some of the visionary power of his youth. For nearly all of those involved throughout their history, however, prints were commercial propositions, and the hope was that everybody concerned would make a profit.

Before the invention of photography, prints were the only means of conveying visual information to a number of people. By prints events were depicted and commented upon, buildings, new and old, were portrayed and knowledge was disseminated. They decorated rooms, taught lessons, presented fashions. The great achievements of the industrial revolution – the first iron bridge at Coalbrookdale, the building of the London to Birmingham railway, the construction of the Menai Bridge – were all commemorated in prints. The tourist guides to the Lakes and Wales were illustrated with prints as were natural history books, engineering and medical treatises, encyclopaedias and periodicals such as the long-running *Gentleman's Magazine*. It is regrettable that in recent years so many beautiful books have been dismembered for the sake of their prints but, as we have said, prints were, and still are, commercial propositions.

It is important to note, however, that the information conveyed

by prints is not necessarily accurate. Sometimes this is due to the process of printmaking itself. With most engravings, for example, the engraver and the artist are different people. The artist may go to Wales and sketch a view on the spot. Later he may work up the sketch into a more finished drawing, possibly emphasising the 'picturesque' elements of the scene or otherwise manipulating the details in the interests of the composition. The drawing goes to the engraver – or possibly to an intermediary who prepares the drawing for the engraver. It has to be redrawn to the size of the plate on which it is engraved in reverse. Eventually proofs are taken and the plate is amended as required. Unless the artist is there to check and alter (*touch*) the proofs, the end product may be a long way removed from his own drawing, which itself may not be an accurate rendering of the scene. Hence the apparent changes which well known buildings seem to have undergone or the otherwise inexplicable shifts in mountain scenery. With etching and lithography this is less likely to happen as in these modes the artist is often also responsible for the work on the plate or stone.

The desire to flatter is another reason why prints may not always be reliable indicators. Obviously this can apply to portraits; but note also those plates dedicated to the owner of the mansion which is depicted or to the winner of the race or the master of the hunt. Sometimes technical inefficiency produces a travesty of the subject matter; there was some poor engraving done especially during the eighteenth century and some very rough work in woodcut at most times.

Overall, however, prints provide wonderful, irreplaceable records of times past and many of them are works of art in their own right. They reflect so much of the age in which they were made: its interests and concerns, fashions and manners, its architecture, activities and leisure pursuits. They also tell us about ways of seeing as well as ways of living, and a knowledge of them is essential to anyone interested in history or art.

2. Understanding and identifying prints

To understand prints you must first be able to identify them. For a print to exist there must be a printing surface – a block of wood, a slab of stone, a sheet of copper or steel – on which the picture or design is incised, drawn or painted in some way; there must be ink, a printing press and paper. The print is, therefore, produced by a process which enables it to be multiplied and involves the use of the hands in the making of the original image. The photographic print is something different; the prints illustrating this book are photographically reproduced. These reproductions

have no value more than a penny or two but the total current value of the originals runs into several thousands of pounds.

To identify prints you need to know how to read them. With many prints this is easy as the necessary information is included on the printed surface. I have a handsome coloured print in front of me as I write. It is clear from the marks and small tears on the bottom edge of the paper that it has come out of a book or from a part or instalment later bound up with others to form a substantial volume. The printed area is bordered by an indented line, the *platemark*, indicating that it was made by an *intaglio* process (see page 10). Above the picture is the word 'BATH' and below it the name of the subject, 'AQUADUCT BRIDGE, CLAVERTON'. Beneath the picture, on the left I read 'J. C. Nattes, del' and on the right 'I. Hill, Aquatinta'. 'Del' is short for *delineavit,* meaning 'drew'; so we know that J. C. Nattes made the original drawing. 'Aquatinta' conveniently tells us that the plate was made by the aquatint process; the aquatint engraver was I. Hill. Centred beneath the picture are the words 'Published 1805 by William Miller, Albemarle Street', which is self-explanatory. If I hold the print up to the light I can see the watermark: 'J. WHATMAN 1801'. Very many prints of this period were made on Whatman paper and you can learn to identify it even if the watermark is not present, as is often the case. It is not hard to discover from reference books that Nattes's Christian names were John Claude, that he lived from 1765 to 1822, that he was a topographical watercolourist (and was expelled from the Old Water Colour Society for exhibiting other men's paintings in his own name) and that our print is Plate XXV of his *Views of Bath.* I. (or J.) Hill (1770-1850) was a well known engraver who worked on some of the coloured books published by Ackermann. The print itself shows John Rennie's classically styled Dundas Aqueduct, carrying the Kennet and Avon Canal over the river Avon, completed only a year before the print was published. The aquatint process is shown by the grainy texture; the printing is almost entirely in shades of brown with touches of blue in the foreground and on the jacket of a man fishing from a boat – this last almost certainly added by hand. It is quite a rare print of good quality.

Another print shows the front of Merton College, Oxford; the words 'Merton College Front' are written on the print itself. There is no platemark, so this has not been made by an intaglio process. On the lower right of the surface of the picture is written 'W. A. Delamotte delt'. William Delamotte (1780-1863) was a moderately well known watercolourist who for a time was drawing master at the Royal Military Academy. Below the picture on the left is printed 'W. Gauci lith'. 'Lith' is an abbreviation for 'lithographer' and can refer either to the printer or to the artist

who transfers the original drawing on to the lithographic stone. In this instance it is the latter; Gauci was a popular lithographer of the mid nineteenth century. Moreover, below the picture on the right it says 'Printed by C. Graf', thereby obviating confusion. We can discover that Charles Graf was at one time 'Lithographer to Her Majesty' and that his works were at 1 Great Castle Street, London. There is no date on this print but a catalogue reference gives 1843. The picture itself is basically black and white with a light yellowish wash; this indicates a tinted lithograph printed from two stones. It is one of a collection of Delamotte's Oxford college views, published as a folio volume. Similar lithographs can be found coloured by hand, either at the time of issue or recently; these are more expensive.

Let us take one more example. This is a small black and white print entitled 'Greta Hall and Keswick Bridge'. The lettering is in English: 'Drawn by W. Westall, A.R.A.' and 'Engraved by E. Francis'. There is no date or publishing information and no platemark but if we look closely we can see that much of the sky is made up of closely ruled parallel lines, that the detail is fine and that there is a sort of silvery effect from the lighter areas, especially the bridge. So this is a line engraving on steel (steel engraving for short). Steel engraving is an intaglio process so there ought to be a platemark. Originally there was one but it has been cut off. The print, as you can find out by looking up the works of Westall, was made for a collection called *Great Britain Illustrated,* published in volume form in 1830. In this collection there were two prints to a page (this print shared a page with 'Dover') and when the sheets were bound up they were trimmed within the platemark. These Westall prints – there are 118 in this volume – are quite common, usually found modern hand-coloured and mounted. The paper is of poorer quality than that used for our other two examples.

A great deal, therefore, can often be learned simply by reading what the print has to say. Here is a short list of some of the abbreviations commonly found on prints:

(Referring to the original artist or draughtsman, usually bottom left)

Del, delt, delin; drew (sometimes by an artist who copied a painting etc, for the engraver).
Descripsit: drew.
Desig, designavit: drew, or designed.
Inv, invenit: designed.
Pinx, pinxit; ping, pingebat: painted.

(Referring to the engraver or etcher, usually bottom right)
Aqua, aquaforti: etched.
Aquatinta: engraved in aquatint by.
F, fecit; fac, faciebat: made by.
Inc, incidit, incidebat: engraved.
Lith, lithog: lithographed by (either the transfer craftsman or the printer).
Sc, sculp, sculpsit, sculpebat: engraved.
There are several more abbreviations used on prints made in Europe.

Other information sometimes given on the printed surface includes: the publisher's name and address, and the date of publication; the name of a series or volume for which the print was especially made (for example, 'For The Beauties of England and Wales'); the number of the print in a series; a dedication to a named individual or public body. Rarely do you find the name of the printer, except on lithographs.

By now we can see that prints were made by a number of different methods. Often they are referred to by the name of the method employed. We have already met aquatint, lithograph and steel engraving; add to these etching, woodcut, wood engraving, mezzotint and copper engraving and we begin to have some idea of the complexity of the subject. The bibliography lists titles of books which deal with the individual processes both practically and historically. Here some simple definitions may be helpful.

Printmaking processes can be divided into three groups: *relief* (including woodcut and wood engraving): *intaglio* (line engraving on copper and steel, aquatint, mezzotint, various types of etching); *planographic* (lithography). Note that in all these processes the image is reversed.

Relief processes
In relief processes the area not to be printed is cut away so that the lines that will carry the ink to be imprinted on the paper stand out in relief from the remainder of the block. *Woodcut* is a comparatively simple process, dating back to medieval times. The design or image is drawn in reverse on a block of smooth, seasoned soft wood and with a knife the cutter removes the wood around and between the lines carrying the design. When the block is completed, ink is dabbed or rolled on; the printing can be done by hand or, with a light pressure, in a press. Albrecht Durer was the great master of the woodcut and the method flourished in the sixteenth century when it was employed for book illustration and embellishment. Since then, however, until the twentieth century, it has been comparatively little used except for ephemeral publications such as broadsheets and street ballads.

In *wood engraving* a block of hard wood is used, boxwood

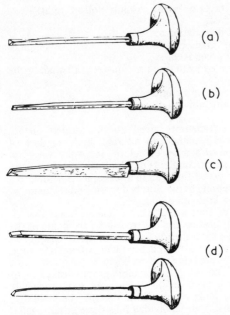

Fig. 3. Tools used by wood engravers, from an illustration in T. H. Fielding's 'Art of Engraving', 1841: (a) square lozenge; (b) extreme lozenge; (c) tint tool; (d) flat or blocking-out tools or chisels.

being the most popular. The wood is engraved with tools similar to the line engraver's burin; far more delicate and detailed effects are possible and the white line may predominate in the composition. Thomas Bewick was the first great master of wood engraving, which became widely used in the mid nineteenth century for book and magazine illustration.

A method of relief printing in metal was used by William Blake.

Intaglio processes

Intaglio processes involve the use of a thin metal plate into which the design is incised in one of a number of ways. The inked plate, with the uncut areas wiped clean, is placed in a roller press operated under considerable pressure to force the paper into the incisions to take up the ink. It is this pressure that leaves the platemark on the paper.

Line engraving has a very long history. The engraver's instrument is a burin or graver, which is pushed across the surface of the plate along the desired line. Until about 1820 the plate was copper; it was possible to obtain several hundred impressions from a copper plate but their quality deteriorated as the plate became worn and reworking of damaged areas by the engraver

10

was often necessary. With the introduction of steel, so much more hard-wearing, this problem disappeared, but steel was also much harder to engrave and necessitated changes in technique. In the late 1850s steel-facing was developed. In this method a copper plate was coated with a thin layer of steel, which, if it ever wore out, could be replaced. The engraver's task was eased by the invention of the ruling machine in the late eighteenth century, especially useful in engraving large numbers of closely parallel lines for areas of sky.

To distinguish between copper and steel engraving, look first at the date of publication of your print. If it is earlier than 1821 it will be copper (the only exceptions being a small number of mezzotints). After 1821, steel soon replaced copper both for the smaller engravings such as book illustrations and the large plates engraved after oil paintings by painters such as Landseer and Wilkie. If your print is undated, it is usually not difficult to distinguish. In copper engravings the parallel lines are further apart, the engraved line looks heavier and the overall 'feel' of the print is warmer. Steel engravings have a silvery feel; the parallel and cross-hatched lines are fine and very close. If you are still in doubt, the simplest thing to do is to compare your print with a known copper or steel engraving.

In *etching* the metal plate (usually copper) is covered with a *ground* made of wax or some similar substance into which the design is drawn with an etching needle. The plate is put into an acid bath. The ground is impervious to acid, which *bites* the exposed lines on the plate for a required length of time, depending on the degree of darkness needed. The plate is removed; the lighter lines are varnished so that the acid will no longer affect them, and the plate is immersed again as required. Plates with a great degree of tonal variation may be immersed ten separate times or more for varying lengths of time. Progress can be checked by the taking of proofs and alterations may be made while the work is in progress. Physically, etching is less demanding than engraving but it is a complicated process and the results are not always what the artist expects. The major compositional lines in prints completed by other processes are often etched and impressions of the etched plates were sometimes published alongside the completed prints; F. C. Lewis's *Scenery of the River Dart* is an example and J. M. W. Turner did much of the preliminary etching, as well as some of the engraving, on the plates for his *Liber Studiorum* and other important sets.

For *aquatint* the outline of the design is usually etched on to the plate at the outset. The aquatint ground is formed of tiny resin particles applied either dissolved in alcohol or as a powder. The plate is then bitten in acid, the lighter areas of tone being *stopped out* with varnish, eight or twelve bites often being needed. The

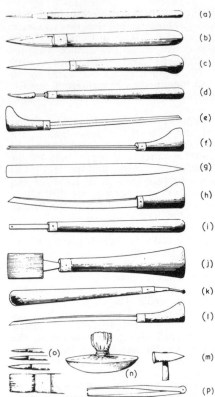

Fig. 4. Etchers' and engravers' tools, from an illustration in T. H. Fielding's 'Art of Engraving', 1841: (a) etching needle; (b) scraper; (c) burnisher; (d) burnisher for mezzotint work; (e) graver, or burin; (f) scooper; (g) scraper for mezzotint; (h) stipple graver; (i) roulette for mezzotint; (j) shading tool for mezzotint; (k) roulette; (l) drypoint or stipple graver; (m) hammer; (n) dabber; (o) brushes, small red sables, large camel hair for applying broad tints of varnish in aquatint; (p) calliper compasses.

effect is to produce tonal variations, the finished prints resembling wash drawings or watercolours. Aquatints could be printed in one or two coloured inks with further colours added by hand. The technique was developed in England in the 1770s, Paul Sandby being the first notable practitioner. It was used to splendid effect in the great range of colour plate books issued by Ackermann and others in London between 1790 and 1830.

Mezzotint works in reverse to other methods in that at first the plate is worked over with a spiked *rocker* until the whole surface is rough. An inked prepared mezzotint plate would produce a rich black image. Areas of the plate are now scraped to required degrees of smoothness. Good impressions, often difficult to print, are few as the roughened area quickly wears, although a skilled mezzotinter could rework worn portions of the plate. The

technique developed in the mid seventeenth century and soon became something of an English speciality, being widely used for portraits. Towards the end of the eighteenth century it also became popular for animal studies and for prints after the paintings of George Morland. In the later years mezzotint was often combined with other processes in so-called *mixed method* prints.

Drypoint is the incising of the design directly into the copper plate with a strong needle. The metal thrown up by the incision – the burr – is left on the plate and prints a rich black, although it very soon wears down. The technique is often combined with others. Rembrandt was the great master of drypoint, which was not much used in Britain until the later nineteenth century.

In *stipple engraving* a pointed instrument is used to build up the image by dotting the etching ground. It was popular in Britain in the late eighteenth century for decorative coloured prints, many of them by Francesco Bartolozzi.

Crayon manner was employed in the late eighteenth century to reproduce or imitate drawings. The etching ground was penetrated by a variety of tools with spiked heads.

Soft-ground etching was quite widely used between 1770 and 1830. The etching ground was mixed with tallow; a sheet of paper was laid over it and the design drawn on the paper with a pencil. When the paper is removed it takes off the ground where the pencil has impressed, leaving a reproduction of the drawing on the plate, which is then bitten in acid.

Planographic processes

Lithography is the chief planographic process and its discovery in 1798 marked the first important development in printmaking for several centuries. It is based on the fact that grease repels water. The design is drawn on a block of limestone with a greasy crayon or ink. The stone is then washed over with water, which is repelled by the greased surfaces. Paper is laid on to the stone in a flat-bed press and the design is transferred. The printing process is highly complicated; the skill of the lithographic printer is a vital component in the production. Alternatives to limestone are aluminium and zinc, both of which are much lighter to handle and became more easily available, and an alternative to drawing directly on to the stone is to make the drawing on specially prepared paper from which the image can be transferred to the stone.

A single stone can satisfactorily print only a single colour. To add to the texture and depth of the picture, a second stone, called a tint stone, was used, usually inked with a pale buff wash. There is no platemark with a lithograph and, even when the printer's name is omitted, it is usually easy to distinguish one from any

other type of print.

The process itself was invented by Alois Senefelder in Munich and was at first known as polyautography. It was not much used in Britain until Charles Joseph Hullmandel set up his lithographic printing press in London in 1818. It soon overtook aquatint for topographical illustration but in Britain it came to attract commercial printers rather than individual artists of note.

Chromolithographs are lithographs printed in colour. Hullmandel developed a method of printing each colour from a separate stone; up to twenty stones might be used for printing a single plate. The maximum weight of stone required for a single book was probably that for J. B. Waring's *Masterpieces of Industrial Art and Sculpture at the International Exhibition*, 1862. This book contained three hundred chromolithographs, for which three thousand stones were necessary.

A note on colour printing

Before the chromolithographs, comparatively few prints were actually printed in colours. A method of inking the plate with different coloured inks was used with stipples and mezzotints while aquatints might be printed in two colours but finished by hand. Experiments using several plates each inked with a different colour – as with chromolithography – were more successful in France than in Britain. There were also experiments with wood block colour, the best known English exponent being George Baxter, whose brightly coloured prints achieved some popularity in the mid nineteenth century.

For the most part, colour was added by hand, either before the print was issued or much later. Engravings of natural history subjects were often coloured on issue, as were the political satires so popular in the reign of George III. This is a difficult area for the new collector and the following points may be useful:

Nearly all intaglio prints (with the exception of some stipples, mezzotints and aquatints) were printed in black and white.

No steel engravings were printed in colour. The many coloured examples that can be found have been tricked up by print dealers in recent years.

In hand-coloured prints the ink lines are black (or sometimes sepia). The ink lines are coloured in prints that were printed in colour.

Prints described as 'coloured lithographs' are likely to be hand-coloured.

'Original hand-coloured' in the description of a print ought to mean what it says. It implies that the printmaker intended the print to be coloured and that this was done at the time of issue. This applies especially to aquatints.

The following paragraph from Alfred Whitman's *Print*

Collector's Handbook (first published in 1901) is worth noting:
'It was the frequent custom towards the end of the eighteenth
and during the early part of the nineteenth centuries, after a
plate had run its course and had been printed from until it was
much the worse for wear, to issue a number of impressions in
colours, so that the colour might divert attention from the poor
condition of the plate.'

On the other hand, sometimes the coloured impressions were
luxury items, the first to be printed at extra cost. The moral is:
look closely and take care.

To distinguish between early and present-day hand colouring is
not always easy unless you know the provenance of the print. For
example, no engraving after J. M. W. Turner was issued coloured,
nor were the steel engravings after William Westall, W. H.
Bartlett, Thomas Allom or any of the Victorian topographers. If
any of these prints are offered for sale coloured, then the
colouring is recent, probably done in the last three decades.
Against this, the prints of John Leech were hand-coloured
on issue and many of these can be found – as illustrations to the
novels of R. S. Surtees or to the 'Comic Histories' of England and
Rome.

If the provenance is unknown or unhelpful and you are still in
doubt about the date of the colouring, then compare your print
with authentic originally hand-coloured prints in museum print
rooms or libraries. This will also help you to guard against being
deceived by a fake. It must be emphasised that modern hand-
coloured engravings are not fakes; the seller is not attempting to
deceive you although the object you are offered is to some extent
a falsification of the original. The fake is a knowing attempt to
deceive and can be understood from the following example.

William Daniell's *A Voyage Round Great Britain* was
published between 1814 and 1825. The original copperplates are
in the possession of a major London gallery. Prints were taken
off them a few years ago and offered for sale in black and white.
There is nothing wrong in this; but there would be something
wrong in obtaining some of these prints, colouring them by hand
in imitation of the original colouring and offering them as
'original' Daniell aquatints. Other instances of engraving frauds
are described in Whitman's book. It is deception with regard to
colour prints (note particularly prints after George Morland and
the many 'Cries of London' issues) that the present-day collector
is most likely to meet, however, as the fakers tend to concentrate
on that which is most in demand.

I have described the modern hand-coloured engraving as a

falsification. It was not the intention of the artist or engraver that the print should be coloured; look at the enormous trouble Turner went to in instructing his engravers how to render colour in shades of black/grey/white. The colours chosen by the modern colourist are quite arbitrary; he is most unlikely to have before him the painting from which the engraving was made – which may have been a wash drawing anyway – and in no way can he see the subject through the original artist's eyes.

Yet there is no denying that tactful hand-colouring can add interest to a dull engraving. I have beside me a small steel engraving, 'Birth Place of Akenside, Butcher Bank, Newcastle-upon-Tyne'. There is no name of artist, engraver or publisher; this print, therefore, is probably a later issue used in a publication for which it was not originally designed. It shows an open-fronted butcher's shop with a few people outside it, and so delicately and carefully has it been coloured that it has a warm attractiveness which, when I first saw it, I found irresistible. But, that said, it is disastrous that so many Victorian books have been destroyed and prints disfigured in the interest of producing a 'decorative' article.

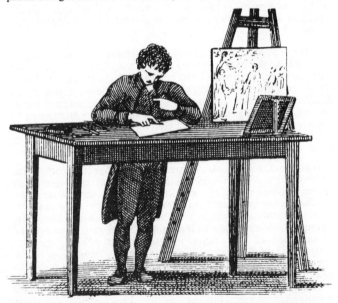

Fig. 5. 'The Engraver', from 'Jack of All Trades', published by Darton and Harvey, 1805. The image of the picture he is engraving is reversed in the looking glass.

3. Changing tastes and values

Tastes change in prints as in everything else and the treasures of one generation can become the discards of another. The 1972 introduction to the reprint of Whitman's *Handbook* gives a fascinating commentary on his chapter on 'The money values of prints' and points out how, since shortly before the First World War, the relative popularity of stipple and aquatint has been reversed. Sporting prints are now in high demand and are costly, as are maritime and railway prints and good topography in almost any medium. Fine mezzotints are scarce; most of them seem to have gone to museums. The products of the 'etching revival' which boomed in the early twentieth century have slumped since, although they are still not cheap.

The point to make is: do not buy prints for investment, but because you like them or they interest you. If you find in later years that your prints have markedly increased in value then that is a bonus. Above all, look at as many prints as possible, learn to read them and recognise them; then you run little risk of being disappointed or defrauded. Get to know your dealers and listen to their advice but your objective should be to learn to use your own judgement based on your own knowledge and experience.

A nice difference between two ages can be seen from a comparison of two catalogues, one issued in 1775 by the printsellers and publishers Sayer and Bennett and the other by a London firm a few years ago. The 1775 catalogue is directed to 'Gentlemen for Furniture, Merchants for Exportation and Shopkeepers to sell again'. The chief printmakers represented are Zoffani (a few theatrical scenes), Macardell (mezzotints), Hogarth, Hollar and the Bucks. The catalogue is divided into subjects: Royal Personages, Scripture Pieces, Naked Figures (only eight), Droll and Humorous Subjects, Of London, various foreign views and so on. They can be bought individually or in sets; mezzotints, posture size (14 inches by 10 inches; 356 mm by 254 mm) are one shilling each and 439 subjects are listed. Sets of 'Six delightful views of Gardens, drawn from Nature' by W. Woollett would cost one guinea plain and two guineas finely coloured. Small prints were very cheap; you could buy all the cathedrals of England and Wales, with the churches of Southwell and Fairford, on thirty copper plates for three shillings the set.

The modern catalogue is devoted to the British Isles, excluding London, and contains well over a thousand items. It is a work of scholarship, with clear and accurate descriptions of each item, some of which are illustrated. Prints by the Bucks appear in both catalogues (Sayer and Bennett had reprinted their complete works). Everything in the modern catalogue is well over a hundred years old; almost everything in the 1775 catalogue is new

or printed very recently. Interestingly, one of the Woollett sets of gardens offered by Sayer and Bennett also appears in the modern list. It comprises four views of the Royal Gardens at Kew. In 1775, as we have seen, it would have cost one guinea, with two extra plates of the Earl of Westmoreland's seat. Two hundred years later the price is £750. Price comparisons of course are meaningless but they are sometimes fascinating.

4. Topographical prints

Topography is the representation of the features of a place. With their cheapness and accessibility, therefore, topographical prints were the only popular means by which people could tell what places looked like. If the print, however, was an engraving, then it was more than likely that the actual producer, the engraver, had never seen the view himself and was merely transcribing on to metal, with the limitations of his tools and his own ability, an impression or interpretation of the scene by someone else. An unscrupulous publisher – Alexander Hogg in the late eighteenth century is an example – might simply order an engraver to copy a print from elsewhere with a few minor alterations so that what was being perpetrated was not too obvious. A worn copperplate might be inexpertly re-engraved. To judge solely from a random collection of engravings, famous buildings such as King's College Chapel or Tintern Abbey changed their proportions frequently in the eighteenth and early nineteenth centuries.

There are other reasons why a print may not be topographically accurate. The print may be an aspect of an aesthetic theory with, say, the main emphasis on the picturesque elements of a scene as in the aquatints of William Gilpin and John Hassell. Or the artist may rearrange the components of a scene in the interest of his composition and of the overall effect he desires, as Turner did in his *Southern Coast* and *England and Wales* series. What should matter most to the seeker is not necessarily the accuracy but rather the quality – of the observation, the interpretation, the craftsmanship and the mechanical process itself.

The first of the important British topographical printmakers was Wenceslaus Hollar, born in Prague, who lived and worked in England, apart from one interval of eight years, from 1636 until his death in 1677. Hollar etched and engraved more than 2,500 plates, including maps, fortifications, costumes and a variety of other subjects as well as topography. As a draughtsman, Hollar was unpretentious, undramatic and keenly observant; his work is sensitively detailed with a conviction of total accuracy. Outstanding are his 'Long View of London', his two views of London before and after the Great Fire, a set of six small views of

Islington, made in 1665, the plates for Dugdale's *Monasticon Anglicanum* and the illustrations of Windsor in Ashmole's study of the *Most Noble Order of the Garter*, 1672. Early impressions of Hollar's prints can sometimes be found although the long views and large prospects are rare and costly. Like several of the earlier artists, Hollar drew, etched and engraved what he himself saw, hence the feeling of authenticity that his prints convey.

Several of the earlier illustrators of English places were born on the continent, including David Loggan, known for his engravings of Oxford and Cambridge colleges published in 1675 and 1690 respectively, and the Dutchman Johannes Kip, whose characteristic views of English country houses were issued in the early eighteenth century. Kip also provided plates for three great county histories: Atkyn's *Gloucestershire*, Chauncy's *Hertfordshire* and Dugdale's *Warwickshire,* to the last of which Hollar also contributed. Many of the earlier annual *Oxford Almanack* illustrations were by another Dutchman, Michael Burghers, although in later years the Almanacks carried engravings after leading English artists including Dayes and Turner.

The greatest topographical undertaking of the mid eighteenth century was the work of the brothers Samuel and Nathaniel Buck. They produced 420 plates of castles, abbeys, palaces and other old and important buildings. These were issued in instalments over a period of about thirty years and were collected and published in three volumes. They also engraved eighty-three large views of cities and towns, known as the 'Prospects'. These are especially interesting as visual records of the times and the later plates give the impression of architectural accuracy. First issues of these works are now very costly but cheap modern reprints can often be obtained from county record offices or libraries. The Bucks' prospects and views make no pretensions to be 'works of art' and features – trees, for example – are merely conventionally represented, but they have much historical value. The brothers also produced an extensive view of London and Westminster in five large plates, which it is fascinating to compare with Hollar's 'Long View'.

There were comparatively few British engravers until some years after the passing of the Copyright Act in 1735. This Act, initiated by Hogarth, gave printmakers some protection and some encouragement to increase their trade. By the 1760s a number of native-born engravers were at work, including leaders of the craft such as William Woollett, a specialist in landscape, and Sir Robert Strange. Illustrated topographical books became popular, with titles such as *England Display'd, England Illustrated, The Antiquities of England and Wales, The Complete English Traveller* and so on. Many of the copper-engraved illustrations appeared under more than one title, and many of them were poorly

executed by overworked engravers trying to make sense of a quickly produced watercolour or wash drawing of a building or landscape they themselves had never seen. Plates from volumes such as these can be easily found and skilful modern hand-colouring can sometimes improve them. Mostly, however, they are lifeless and inaccurate, quaintness being their only recommendation.

Better work appeared in *The Copper Plate Magazine*, a monthly periodical of the 1770s published by G. Kearsley, which included some landscapes after drawings by Paul Sandby, engraved by Michael Rooker. In 1778 the same publisher produced *The Virtuosi's Museum* with 108 plates after Sandby by Rooker, Fittler, Angus and other leading engravers. This was made up from thirty-six parts containing three plates in each, described as 'elegant engravings from one of the leading artists in the kingdom at the very moderate price of One Shilling for each plate'. Many of these prints were reissued in John Walker's revival of *The Copper Plate Magazine,* 1792-1802, but the fullest collection of Sandby's engraved work was in *Select Views in England, Scotland and Ireland,* published by John Boydell in volume form in 1781, with 150 Sandby prints. Be wary of coloured prints after Sandby with the imprint of Palser of Westminster Bridge Road; these were taken from worn plates and the quality is poor. Paul Sandby is an important figure in the history of British painting and engraving. He was an originator of the Royal Academy and drawing master to the sons of George III and, as such, he gave the technique of watercolour a status almost equivalent to that of oil painting. As an etcher and engraver himself he knew how to produce originals that would make effective prints; he was also mainly responsible for developing the aquatint process with twenty-four views of scenes in Wales and a few large and splendid plates of town views and military encampments.

John Walker's *Magazine* also included work by fine painters such as Edward Dayes, John Varley, William Turner, Thomas Girtin and J. M. W. Turner. Walker engraved many of the plates himself; a few years later, repaired and touched up, they were republished in *The Itinerant*. The Turner and Girtin plates, patched up again and again, were still being used as late as 1873 – worth noting, if you think you have found a bargain.

As an engraver, Walker was no more than mediocre. The best of the time included William Byrne (engraver of Thomas Hearne's drawings for *The Antiquities of Great Britain*, an above-average publication), William Watts (*Views of Gentlemen's Seats*), Thomas Milton, Wilson Lowry and the Frenchman Francis Vivares. Wilson Lowry invented the ruling machine, which took much of the labour out of engraving large areas of sky.

He engraved two of George Robertson's paintings of industrial scenes in Coalbrookdale, published by Boydell in 1788, powerful contrasts to the usual pastoral or architectural subjects.

John Boydell was the leading publisher of prints and illustrated topography in the second half of the eighteenth century. He was trained as an engraver and published his own collection of 152 views of English and Welsh scenery in 1751, reissuing them in 1790, when, to all but the least critical, they must have looked dated. As he built up his business he commissioned engravers to make prints from old master paintings and paid painters especially to produce work to be engraved. With his nephew Josiah he published *The Shakespeare Gallery,* a set of prints after paintings commissioned to illustrate scenes from Shakespeare's plays, and *The Houghton Gallery,* engravings after paintings amassed by Sir Robert Walpole at Houghton Hall but later sold by the third Lord Orford to Catharine the Great of Russia.

Boydell published some of the early colour-plate books, including the well known *History of the River Thames* with seventy-six aquatints by J. C. Stadler after the drawings of Joseph Farington, and built up a flourishing export trade in British prints. In 1790 he became Lord Mayor of London. Within a few years, however, the troubles in France destroyed the export market and his business collapsed. Boydell fought to clear his debts and succeeded in doing so before he died in 1804. For several decades he had been, in effect, the greatest patron of his age, bringing employment and sometimes much wealth to countless painters and engravers.

In 1795 Rudolf Ackermann, having emigrated from Germany, opened a print shop in the Strand. Soon this shop, the Repository of Arts, became a focal point of the print and publishing trades. Ackermann specialised in colour-plate books, the plates being engraved in aquatint, printed in one or two basic colours and finished by hand – for which he employed a large number of colourists, many of them emigrés like himself. He followed the usual practice of issuing the works in instalments and then collecting them into volumes.

The major Ackermann publications include the following:

The Microcosm of London, 1810, with 104 plates after A. Pugin and Thomas Rowlandson.

The University of Oxford, 1814, with sixty-four plates after Pugin, Mackenzie, Nash and William Westall.

The University of Cambridge, 1815, sixty-four plates after Pugin, Mackenzie and Westall.

The History of. the Colleges of Winchester, Eton, etc (public schools), 1818, forty-four plates after Pugin, Mackenzie and Westall.

Picturesque Tour of the English Lakes, 1821, forty-eight plates

after T. H. Fielding and J. Walton.
Picturesque Tour of the River Thames, 1828, twenty-four plates after Westall and Samuel Owen.

Aquatint was also used for the *Repository of Fine Arts* magazine, which appeared between 1809 and 1828 with illustrations on a wide variety of subjects. Ackermann also encouraged lithography; some of the later issues of the *Repository* contain lithographs and he was the publisher of the key work on the subject, *The Complete Course of Lithography* by Alois Senefelder, in 1819.

Ackermann employed first-class engravers, including J. Bluck, J. C. Stadler, T. Sutherland and R. G. Reeve. He did not have a monopoly of the coloured aquatint, however. Although all his publications are of high quality, some of the very finest work appeared over other imprints. Philip De Loutherbourg's *Romantic and Picturesque Scenery of England and Wales,* 1805, with eighteen superb plates engraved by W. Pickett, was published by Robert Bowyer. Robert Havell engraved and published his brother William's *Picturesque Views of the Thames*; these twelve plates are perhaps the finest and certainly the most expensive of all the coloured prints of the river. Thomas Malton published his own aquatints of London views, as did several engravers, while among other publishers of aquatints were S. W. Fores and E. Orme.

It is William Daniell's *A Voyage Round Great Britain,* however, that has been described as 'the most important colour plate work of British topography'. This appeared in parts between 1814 and 1825 as Daniell and Richard Ayton, his companion for the first quarter of the tour, finished each stage in their journey. The 308 plates were engraved by Daniell after his own drawings; they were printed in brown and blue-grey and hand-coloured by the firm of William Timms. The *Voyage* began and ended at Land's End and comprises views of coastal scenery with shipping, lighthouses, men at work or with their ladies enjoying the view. In compositional quality and colouring the plates are remarkably consistent; the tonal range is limited but has a delicacy that no other aquatints have achieved. The *Voyage* was published by Longman, Hurst, Rees, Orme and Brown; the parts were collected into four handsome volumes.

Plates from all these publications can still be found without too much difficulty. The Havell and De Loutherbourg prints are more expensive; the others tend to vary according to the subject rather than the quality of the individual print. Ackermann *Cambridge* plates are more costly than *Oxford*; in a recent list, Downing College cost nearly three times as much as All Souls'.

Not all aquatints were issued coloured; some were printed in tones of grey or sepia and others were tinted. The books of the

Reverend William Gilpin, who expounded in great detail the theory of the 'picturesque', were illustrated by aquatints after his own drawings in which the subjects are organised to demonstrate his ideas. More successful as pictures were the aquatints published later by Orme under the title *Gilpin's Day*. Sepia aquatints illustrated the tours of Samuel Ireland along the Wye, Thames, Medway and Avon; the draughtsmanship is routine, as is the engraving, but some of these prints have a period charm and they are still comparatively cheap. Sepia aquatints were also used by Thomas Hosmer Shepherd in his engravings of paintings made in 1669 illustrating the *Travels of Cosmo the Third,* written in Italian but not translated or published in England until 1821. The painter Frederic Christian Lewis translated his own paintings into sepia aquatint for *Scenery of the River Dart*, 1820. John Hassell used all varieties of aquatint for his own publications, but none of them very well. Those accompanying his *Tour of the Isle of Wight* are really rather nasty, but this was one of his earliest works.

As steel engraving rapidly displaced copper, so lithography overtook aquatint in the 1830s. Indeed, William Westall used lithography for his *Thirty Five Views on the Thames*, which began publication in 1821. The technique was rapid and, once the press had been set up, comparatively cheap, but it had less attraction for good artists in England than it had in France. Prints by Westall, Samuel Prout and James Duffield Harding are worth looking for, but you are more likely to find lithographs by Francis Nicholson, who made over eight hundred of them of little distinction.

With lithography, the quality of the printing was all-important. Names of printers to note are Hullmandel, Day, Englemann, Graf, Dickinson, Gambart and Hanhart, but there were many more; in 1851, the Post Office listed 135 lithographic printers in London. Many lithographs were printed in London but published in the provinces; a local view, therefore, may carry the name of a local publisher and a London printer – but frequently the name of the artist is omitted altogether. Nevertheless, the topographical lithograph is more likely to be accurate than an engraving in view of the nature of the technique, and this indicates the historical importance that many 'local' lithographs possess. Their rarity today, however, seems inexplicable; where on earth have they all gone to?

Some of the most interesting lithographic work is referred to in Chapter 5, on transport. Otherwise, good lithographs include the plates of *Britannia Delineata,* the Lake District views of J. B. Pyne, lithographed by T. Picken, J. P. Lawson's *Scotland Delineated,* George Hawkins's fine studies of the bridges over the Menai Straits and J. Arnout's views of English towns. Best of all

are the plates of *Original Views of London As It Is*, by Thomas Shotter Boys, 1842. Boys had already made coloured lithographs of the architecture of various European capitals but for the London scenes he used only two stones, one for the outline and the other a tint stone. Some of the plates were then hand-coloured but the volume as published was left plain. These plates give a detailed and precise record of London architecture and life. Boys's *Original Views* makes a splendid companion to Ackermann's *Microcosm* of thirty years before.

To resume the story of engraved work, we have to go back to the early years of the nineteenth century and to the activities of the writer and publisher John Britton. He came to topography through writing descriptions for Walker's *Magazine*, and before long he set out on his own undertakings. Among his principal completed projects were most of the twenty-five volumes of *The Beauties of England and Wales* (with E. W. Brayley), which contained over seven hundred engravings, *The Architectural Antiquities of Great Britain* (about 350 plates), *The Cathedral Antiquities of England* (311 plates), *Picturesque Views of English Cities* (thirty-two plates after G. F. Robson) and *Picturesque Antiquities of English Cities* (sixty plates). Britton continued to publish books illustrated with copper engravings throughout the 1820s, when most publishers had turned to the cheaper and more durable steel, and he always aimed at achieving the highest standards of accuracy and book production.

Britton employed most, if not all, of the leading engravers of his time. Among them were George and William Cooke, who together produced the seventy-five plates of *Thames Scenery*, 1818. Between 1814 and 1826 they brought out the sixteen parts of *Picturesque Views on the Southern Coast of England*, which included forty plates after J. M. W. Turner and appeared in volume form in 1826. Turner's work had appeared in a number of publications previously but – apart from the mezzotints of the *Liber Studiorum* – this was the first major collection. Turner closely supervised the work of the engravers, who included William Miller, Edward Goodall, W. Radclyffe, J. C. Allen and John Horsburgh as well as the Cookes, and the result was plates of a tonal range and quality never before realised in black and white. Other works with copper engravings after Turner included Whitaker's *History of Richmondshire*, Walter Scott's *Provincial Antiquities* and *Border Antiquities of Scotland* and, most important of all, *Picturesque Views in England and Wales*. Most of the *Southern Coast* engravers also contributed to this, with the addition of R. Wallis, James Willmore, J. C. Varrall, Robert Brandard (engraver also of 'Crossing the Brook'), Thomas Jeavons, J. H. Kernot and a few more. For each drawing Turner received between sixty and seventy guineas (he had been paid two

guineas for each of his *Copper Plate Magazine* drawings), while the engravers were paid up to £100 for each plate. Prices for the various versions of the first collected volume of sixty plates ranged from £48 to ten guineas. Owing to lack of demand, however, the series ended with ninety-six plates instead of the hundred and twenty originally planned. By this time there was a surfeit of 'picturesque views', mostly much cheaper than Turner's as they were engraved on steel. The publisher, Charles Heath, was almost ruined by the failure of the undertaking and Turner himself bought up the unsold prints and the copperplates, to prevent them being reissued. After Turner's death they were destroyed.

Both the watercolours and the engravings for the *Picturesque Views* stand at the summit of achievement in their respective fields. The reputation of the engravings, however, has suffered partly because Turner himself took so many of the proofs and partly because the plates themselves wore down so quickly. Good impressions are hard to come by and hand-coloured examples are disastrous, especially when one considers the care taken by Turner to ensure the translation of his own coloured original into black and white. The *Southern Coast* plates suffered still more as they were reprinted many times. Of the late impressions, only those by J. C. Armytage, who reworked the plates, are acceptable but they too lack the subtlety of the early pulls. Be wary of the *Turner Gallery* plates, published in 1859, eight years after Turner's death. Although the engravers include many who worked under Turner's direction, these are not the plates that Turner 'touched'.

It is, however, neither very difficult nor expensive to obtain a first-class sample of Turner's engraved work. With the rapid development of steel engraving he was much employed in book illustration; editions of the poems of Milton, Walter Scott and Samuel Rogers published in the late 1820s and 1830s are embellished with his designs in vignettes by some of the leading engravers, including Henry Le Quex, the Cousens, the Findens and many of his own team. His illustrations also appeared in several of the popular Annuals, including *The Keepsake, The Anniversary* and *Turner's Annual Tour,* but in these the quality of both composition and printing was variable. Although the steel plates could withstand thousands of impressions, the production was often hurried and unsatisfactory. A good edition of Rogers or Scott, however, with Turner's illustrations is well worth looking out for.

Steel engraving was the dominant illustrative process between, approximately, 1825 and 1845 and most of the topographical prints that are bought today are steel engravings from this period. They were published in parts, in volume form and sometimes as ordinary single prints or 'proofs' at an increased price. The artists

whose work is most commonly met include Thomas Allom, William Westall, David Cox, Henry Gastineau (the last two specialists in Welsh views) and, the most prolific by far, William Henry Bartlett. Between 1828 and his death in 1854 Bartlett contributed to a remarkable number of volumes, including Wright's *Essex,* Beattie's *Castles and Abbeys of England,* the three volumes of *Syria, the Holy Land, Asia Minor* etc, Van Kempen's *Holland and Belgium,* Willis's *American Scenery* and *Canadian Scenery,* the second volume of Finden's *Ports and Harbours, Scotland Illustrated, The Scenery and Antiquities of Ireland, The Beauties of the Bosphorus, The Christian in Palestine, Footsteps of Our Lord, Forty Days in the Desert,* and several more. Exceptionally, Bartlett travelled to all the places he drew, unlike many of his contemporaries who worked up their pictures from sketches by others. His output was prodigious, almost all of it destined for the engravers at the behest of a publisher. Only six of his paintings were exhibited at London galleries during his lifetime. It is not surprising, therefore, that Bartlett's is the name most often found at the bottom left-hand corner of topographical prints of this period.

Certain geographical areas have their own specialists. The northern counties of England are largely represented by Thomas Allom; Samuel Prout is mainly associated with Devon and Thomas Hosmer Shepherd with London and Edinburgh. Henry Gastineau made over two hundred drawings for *Wales Illustrated,* and the Isle of Wight became virtually the province of the Brannon family. William Westall's *Great Britain Illustrated* is typical of the more general collections; this contains 118 views on fifty-nine plates, engraved by or under the direction of Edward Finden. It appeared in parts from 1828 to 1830, being published as a single volume in the latter year and in two smaller volumes shortly afterwards. The prints are well engraved and interesting in an undemanding way; mostly the artist is content to record plainly what he sees, with the addition of a conventional group of figures to balance the composition. Rarely – as with the Barnard Castle view – is there an attempt to dramatise the scene; it is a placid Britain that Westall presents, with only a few signs of well ordered industrial activity.

Among the more interesting collections of topographical steel engravings are Clarkson Stanfield's *Coast Scenery,* with forty finely engraved plates after his own paintings, Roscoe's *North* and *South Wales,* totalling ninety-eight plates, all engraved by W. Radclyffe, and Finden's *Ports and Harbours,* especially the first volume, which includes among the fifty plates seven after the beautifully detailed work of E. W. Cooke. An exceptional publication was Tombleson's *Thames,* with text by W. G. Fearnside. This was published in both London and Karlsruhe and

contains eighty plates of the Thames and Medway by a variety of engravers after William Tombleson's own drawings. The plates are adequate but not outstanding; however, they are given distinction by their extremely attractive decorative borders, each one different and each appropriate in some way to the place shown in the print: Oxford has college coats of arms, Eton is bordered by samples of the chapel architecture, Windsor has regal impedimenta, Chatham details of men of war and uniforms, and so on. Their borders alone place the plates of Tombleson's *Thames* among the triumphs of steel engraving.

With the spread of the railway system came a vast increase in guide books. Steel engravings were used to illustrate the more costly of these, usually with woodcuts (which could be printed with the text) as well. Another by-product of the railway age was the series of steel-engraved vignettes with titles such as *Views in Cornwall, Thirty Views of Hastings and St Leonards* or *Six Views of this Neighbourhood*. The same vignettes might also appear in guide books or on notepaper. One of the largest publishers of these was the firm of Rock and Company; the views are identified with a reference number but otherwise are often anonymous. Newman and Company and J. and F. Harwood were other firms issuing these series. Although it is unusual to find unbroken sets today, the individual vignettes are quite common, but with hand-colouring and substantial mounts they may not at first be recognisable for what they are.

5. Sporting and transport prints

Prints of sporting subjects were among the most characteristic products of English printmakers. They reflected the tastes and activities – perhaps the obsessions – of the English gentry as well as demonstrating the difficulties of picturing a horse at full gallop. Sporting prints had no pretensions to being works of art; they showed things happening, usually with identified people and animals, and the sense of immediacy many of them convey is remarkable when one remembers the complexity of the processes involved. Most of the best sporting prints are coloured aquatints, but mezzotints, sometimes coloured, and coloured lithographs can also be found. Good early impressions are, however, rare and expensive today; it is later or modern reissues that you are likely to discover, sometimes made from the original plates faced with steel and hand-coloured. And you may see an early impression, heavily framed, on the wall of a country hotel or pub, usually foxed and faded, a shadow of its former self.

Hunting and horse racing

Hunting and horse racing were by far the most popular sports.
James Seymour (1702-52) was an early painter of horses, and sets
of mezzotints and line engravings after his sketches were
published before the development of aquatint. After his death,
horse portrait painting was dominated for some years by Francis
Sartorius; among his best known works is a picture of Diomed,
winner of the first Derby in 1780. A greater artist than either of
these, George Stubbs, made several studies of horses, many of
which he engraved himself. But in the world of the popular
coloured aquatints of hunting and racing scenes the great names
are those of Henry Alken, James Pollard, John Frederick
Herring, Dean Wolstenholme, Charles Hunt, F. C. Turner, John
Ferneley and Jacques Laurent Agasse. Thomas Rowlandson
added his own blend of vigour and critical social observation to
the sporting scene, his etched-outline aquatints being among the
earliest and most desirable of the coloured prints.

With many of these prints, however, the least successful
element is often the depiction of the horses themselves. This is
especially so of the scenes showing the finish of a race, with all the
horses in identical attitudes, legs at full stretch and bellies almost
touching the ground. F. C. Turner was one of those who had
particular difficulty in working out what happened to a horse's legs
while galloping, and even Stubbs's portrayals sometimes lack
conviction. Pollard's view of the 1833 Derby shows more than
twenty horses approaching Tattenham Corner, all in exactly the
same posture and all being ridden in exactly the same way. In
many of these prints the background is at least as interesting as
the foreground, the artists devoting much care and attention to
the buildings, fashions and, especially in the hunting prints, the
landscape. The *National Races* series published by Ackermann
shows the racing scene throughout Britain in the 1840s and 1850s,
while the villages of Hertfordshire are shown with affection and
accuracy in a set of aquatints engraved by Dean Wolstenholme
junior after his father's originals. Leicestershire becomes a
familiar county through the work of Ferneley and Henry Alken's
Quorn Hunt series, while the country hunted by the Beaufort,
who wore green instead of the usual hunting pink, is lovingly
shown by the amateur painter Walter Parry Hodges, whose
designs were engraved by, among others, Henry Alken himself.

Many of the racing and hunting prints also incorporated
portraits of the riders, whose names were often included in the
subscription. Alken's 'Grand Leicestershire Steeplechase', for
example, gives the names of the owners, horses and riders at the
start, including also Mr Barclay, the starter. Some of them
illustrate celebrated incidents on the racecourse or hunting field.
'The Memorable Contest between Bonny Fit Lad, Sprig of

Talent, Slim Harry and Tom Dross' at the Northumberland races in 1826 and 'G. Osbaldeston Esq performing his wonderful and unprecedented feat of 200 miles against Time' are two examples of the journalistic approach of printmakers. Prints of winners of the major races were in the shops as soon as possible after the event, usually within a few weeks.

Popular also were sets of prints that told stories or illustrated a sequence of events. *The Life of a Race Horse* after Charles Ansell was an early set, first published in 1784; this theme was followed by several artists, including Rowlandson and Pollard, using four or six plates showing the racehorse's decline from winning to drawing a cart. Alken's *The First Steeplechase on Record*, a set of four plates engraved by J. Harris, was reissued many times and is perhaps the best known of all the hunting series. Edward Duncan engraved a set of ten plates after John Ferneley, illustrating *Count Sandor's Exploits in Leicestershire*. Other series include *A Trip to Melton Mowbray*, twelve aquatints after Sir John Dean Paul, *A Celebrated Fox Hunt* and *Chances of the Steeple Chase* after James Pollard, Herring's *Fox Hunting Scenes* and a host more after Henry Alken.

Coaching prints

Many coaching prints were produced in the early decades of the nineteenth century, mostly by the same artists and engravers who excelled in racing and hunting scenes. Those after James Pollard are always in great demand, among the best known being 'The Elephant and Castle on the Brighton Road', engraved by T. Fielding, a lively scene showing eleven vehicles loading or manoeuvring in front of the famous inn, and 'Approach to Christmas', engraved by George Hunt, wonderfully evocative, the archetypal Christmas-card view. Pollard shows the famous mail coaches outside the great coaching inns: the Royal Mails preparing to start at the Swan with Two Necks, the Cambridge Telegraph outside the White Horse, the North Country Mails passing the Peacock at Islington. In a series entitled *Incidents in Mail Coach Travel* he depicts some of the difficulties and hazards faced by coaches and their passsengers in floods and blizzards. Good coaching prints were also produced by Charles Hunt and after the drawings of J. L. Agasse; other names to look out for are C. B. Newhouse and W. J. Shayer.

Other sports

In an age dominated by the horse, other sports drew comparatively little attention. There are four fishing plates after James Pollard, of extreme rarity, showing top-hatted anglers on the Lea, and three plates in the *National Sports of Great Britain* series, 1821, engraved by John Clark after Henry Alken. There

are some attractive shooting scenes after Morland and Henry Alken, a few from the latter's *National Sports* set, and both shooting and hunting are represented in E. Orme's splendid publication *British Field Sports*, twenty aquatints after Samuel Howitt, mostly by J. Godby and H. Merke. This was originally published in ten parts; a first edition of 1807 was offered for sale in 1981, under the description of 'the finest and most important sporting book of the last two centuries'. An earlier Howitt publication, *The British Sportsman,* with seventy-two etched plates, has quality but less splendour.

Boxing – or rather prizefighting – was the subject of one exceptional aquatint, 'The Interior of the Fives Court in St Martins Lane with Randall and Turner sparring', by Charles Turner after C. Blake, 1821. This included portraits of many famous sportsmen of the day, most of whom, in order to be recognisable, have their backs to the ring. There are a few plates of matches, but most of the prints to be found are mezzotints or stipple engravings of individual fighters, posed ready for combat. Cricket is also scantily treated. There is a well known early engraving by William Benoist after a painting by Francis Hayman, 1743, and a hilarious Rowlandson etching of 1811, 'Rural Sports, or a Cricket Match Extraordinary', showing a ladies' match between Hampshire and Surrey. Several portraits and lithographs were produced in the mid nineteenth century.

Prints were used to illustrate many of the sporting periodicals and books. The *Sporting Magazine,* first issued in 1793, covered a range of sports and was illustrated by engravings. C. J. Apperley, better known as 'Nimrod', wrote for later numbers, his articles often illustrated by Henry Alken, whose prints also accompanied Nimrod's contributions to the *Quarterly Review.* Nimrod and Alken also contributed to the *Sporting Review,* 1839-70. Books illustrated by coloured prints included Geoffrey Gambado's *An Academy for Grown Horsemen,* with prints by Rowlandson after Henry Bunbury; *Real Life in London*, illustrated by Henry Alken; *Life in London,* by Pierce Egan, containing the adventures of Tom, Jerry and Logic, with thirty-six aquatints, mostly by Robert and George Cruikshank, many of them sporting in that they showed the heroes watching cockfighting, ratting or gambling; Nimrod's *Life of John Mytton,* with Alken's plates; and the many volumes by Robert Surtees, including *Handley Cross, Jorrocks's Jaunts and Jollities* and *Mr Sponge's Sporting Tour*, illustrated mostly by John Leech. Plates from the various editions of these volumes are still plentiful and quite cheap.

Transport: canals

Compared to other modes of transport, canals were poorly treated by the illustrators. The first spectacular engineering work,

the Barton Aqueduct, opened in 1761 over the Bridgewater Canal, was depicted in a few line engravings of highly dubious accuracy and little artistic merit. Another early view was an engraving of Stourport in 1776, a canal town developed after the opening of the Staffordshire and Worcestershire Canal in 1772. Not being considered at all picturesque however, canals were largely ignored by artists of any pretension.

The major aqueducts built around 1800 did attract some attention. As well as Hill's aquatint of the Dundas Aqueduct on the Kennet and Avon Canal there are splendid aquatints by F. Jukes after J. Parry's views of the aqueducts at Marple and Pontcysyllte. The great aqueduct at Pontcysyllte was the subject of at least a dozen plates in different media.

Of the canals themselves, only the Grand Junction and the Regent's were widely illustrated. In 1819 John Hassell's *Tour of the Grand Junction* was published with twenty-four aquatints, coloured in most issues. These are quaint little pictures which give little idea of the operation of the canal; like the authors of the early railway guides, Hassell was more interested in the surrounding scenery and the great houses than in the transport system he was ostensibly concerned with. A livelier scene was Laurie and Whittle's 'View of the First Bridge at Paddington and the Accommodation Barge going down the Grand Junction Canal', published in 1801. More reliable are plates from Ackermann's *Repository* of the City Basin and the Islington tunnel and a fine large aquatint by J. Jeakes after H. Milbourne showing Paddington Basin in 1801.

Perhaps the finest set of aquatints of canal scenes is the six views in *A Picturesque Tour of the Regent's Canal* engraved by J. Cleghorn after watercolours by Thomas Hosmer Shepherd, published in 1825. Variations on these views appeared as steel engravings in *Metropolitan Improvements*, the best known of all canal prints, as well as being good prints by any standard. Unlike Hassell's scenes, the Shepherd prints convey much information about the way canals worked, even to the names of the boats and the carriers.

The lithographers seem to have avoided canals generally, apart from an incidental view included in a railway scene. S. Russell's 'Bridge under the Cromford Canal at Bull Bridge' may be unique in giving equal prominence to both means of transport; more usually, the railway is striding exultantly over the sleepy canal beneath. Occasionally canal scenes are found in collections devoted to rivers: there are views of the Thames and Severn Canal in Farington's *History of the River Thames*, in Samuel Ireland's *Picturesque Views on the Thames,* and in Cooke's *Thames Scenery*. Steel engravings occur from time to time in the popular collections such as Westall's *Great Britain Illustrated,* which

includes canal scenes at Hythe and Calne, and Thomas Allom illustrated the Bridgewater Canal, the Caledonian Canal and the Rolle (or Torrington) Canal in various books. There are also several woodcuts of canal life that appeared in the *Graphic* and the *Illustrated London News,* notably of the explosion of the gunpowder boat on the Regent's Canal by Macclesfield Bridge.

Railways

The railway brought glamour and vitality to the nation's transport system. The early development of railways in Britain coincided with the perfection of the techniques of lithography; most of the important railway prints are lithographs, with a smaller number of aquatints and line engravings. The subject, however, did not attract the better-known artists; it also presented its own difficulties, both in the matter of perspective and in the depiction of machinery in motion. Railways, moreover, were contentious, with widespread opposition in Parliament and press to the opening in particular of the Liverpool and Manchester line in 1830. This opposition was expressed visually by the cartoonists, including the Cruikshank brothers and Henry Alken, with an emphasis on dangers and disasters. In contrast, most of the 'serious' prints of railways showed them operating in a picturesque serenity. That deception was sometimes at work is shown by an aquatint of 'The Locomotive Engine and Train of the Birmingham and Liverpool Rail Road' after S. Bourne, published in 1825 – twelve years before the line was completed! This shows two trains travelling in the same direction less than a hundred yards apart, with sheep and cattle grazing within a few yards of the line and no smoke issuing from either locomotive.

For railway prints the year 1831 was especially important. Plates of locomotives and railway scenes had been published previously, including lithographs of the opening of the Stockton and Darlington Railway, 1825, and the Canterbury and Whitstable, 1830. To mark the opening of the Liverpool and Manchester, Ackermann published *Six Coloured Views of the Liverpool and Manchester Railway,* engraved in aquatint by S. G. Hughes and H. Pyall after drawings by Thomas Talbot Bury. Further plates were added later in the year to make a total of thirteen. These were reissued and re-engraved several times and include the famous print of 'The Tunnel' which in its first issue showed a locomotive steaming through drawing a line of trucks – a clear breach of an Act of Parliament which laid down that steam was not to be used in tunnels, through which wagons had to be hauled by cable. It took four impressions before the locomotive finally disappeared from the plate. In the same year Ackermann published two aquatints by Hughes after I. Shaw, *Travelling on the Liverpool and Manchester Railway*, which have

1. Dundas Aqueduct: aquatint by I. Hill after J. C. Nattes, published 1805. This is plate XXV of Nattes's 'Views of Bath'. (See Chapter 1.)
2. Greta Hall and Keswick Bridge: steel engraving by E. Francis after William Westall, published in 'Great Britain Illustrated', 1830. (See Chapter 1.)

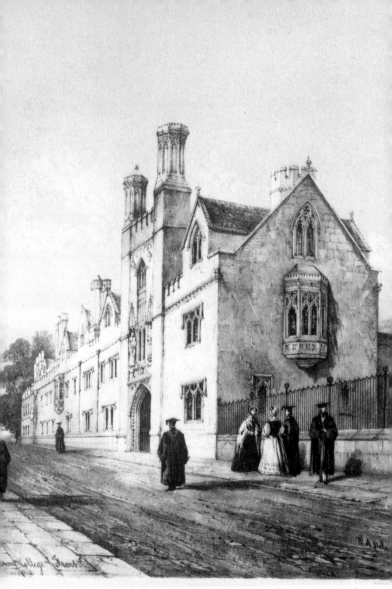

3. Merton College, Oxford: lithograph by W. Gauci after W. A. Delamotte, 1843. (See Chapter 1.)

4. (above). Enlargement of the top left-hand corner of plate 5, showing the wood engraver's free technique of handling areas of sky.

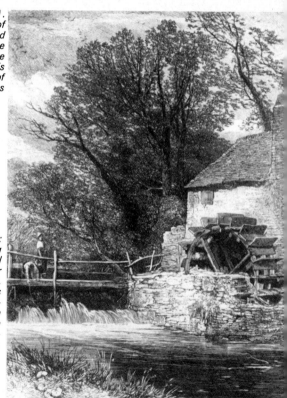

5. Watermill: wood engraving by the Dalziel brothers after Birket Foster. From 'Pictures of English Landscape' with verses by Tom Taylor, published in the 1860s.

6. Sleaford: copper engraving by John Walker after an original drawing by William Brand, published 1798 in Walker's 'Copper Plate Magazine'. This shows the turn-round point on the Sleaford Navigation; the mill has gone, but otherwise the scene is easily recognisable.

7. Enlargement of a section of sky from plate 6.

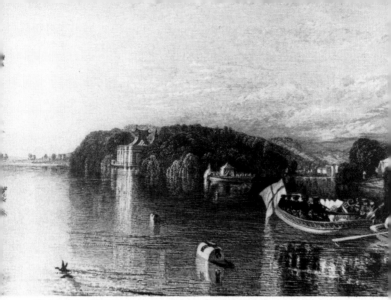

8. Virginia Water: steel engraving by R. Wallis after J. M. W. Turner.
This was engraved for one of the many 'Annuals' popular in the 1830s.

9. Enlargement of a section of sky from plate 8, to compare with plate
7.

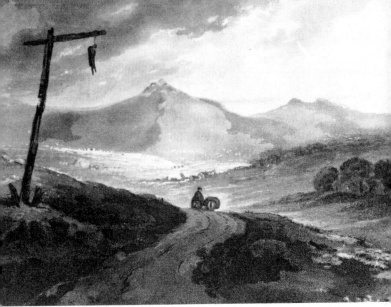

10. Plate 18 from 'Gilpin's Day', a set of aquatints by Hamble and Dubourg after drawings by William Gilpin, published by Edward Orme in 1810. This is an effective example of Gilpin's picturesque interpretation of landscape.

11. Enlargement of the right-hand section of plate 10, showing the characteristic aquatint grain.

12. *The Young Waltonians or Stratford Mill: mezzotint by David Lucas after the painting by John Constable, first exhibited 1820. One of Lucas's few large plates after Constable.*

13. *Enlargement of the lower central section of plate 13 showing the tonal range of mezzotint.*

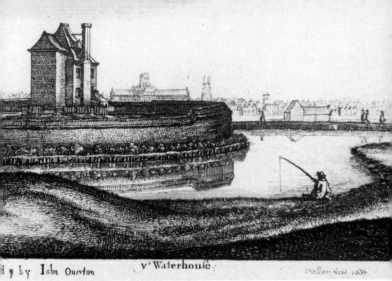

14. *The Waterhouse at Islington, one of a set of six etchings of this subject by Wenceslaus Hollar, 1634. Old St Paul's can be seen in the middle distance.*

15. *Section of a lithograph, Llanthony Abbey, by Samuel Prout, from 'Castles and Abbeys of Monmouthshire', 1838. A tinted lithograph printed from two stones kept in register by the pinprick visible in the bottom left-hand corner.*

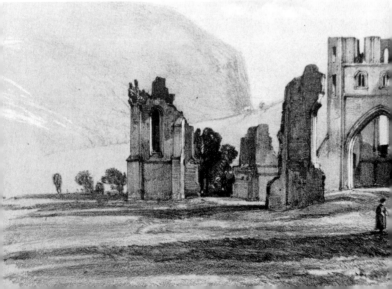

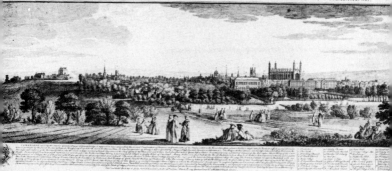

16. North-West Prospect of the University and Town of Cambridge, etched and engraved by Samuel and Nathaniel Buck, 1743. The major buildings are identified by the key below.

17. Gillingham church, Norfolk: copper engraving by Potes after a drawing by J. P. Neale. A characteristic example of the 684 illustrations to 'The Beauties of England and Wales' by J. Britton, E. W. Brayley and J. Brewer, published in twenty-six volumes in the early years of the nineteenth century.

18. Water Engine, Coldbath Fields Prison: aquatint by J. Bluck after
Pugin and Rowlandson, from Ackermann's 'Microcosm of London',
1808. The engine raised water from the Fleet river and the prison was
situated near Mount Pleasant sorting office.

19. *St Peter's College (Peterhouse), Cambridge: aquatint by J. C. Stadler after Pugin, from Ackermann's 'Cambridge', 1815. The water channels leading to Hobson's Conduit, then sited in Market Square, can be seen on either side of Trumpington Street.*
20. *Lighthouse on Point of Air: aquatint by and after William Daniell from 'A Voyage Round Great Britain', 1815. The lighthouse is at the mouth of the river Dee, Clwyd.*

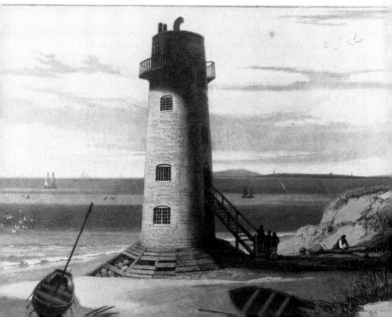

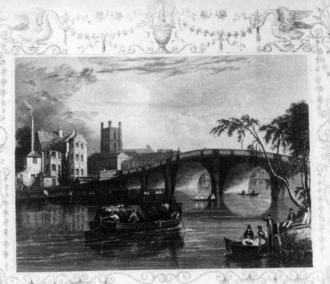

21. Henley: steel engraving from W. Tombleson's 'Eighty Views of the Thames and Medway', first published 1834. The decorative borders are a feature of this collection.

22. Pontcysyllte Aqueduct: lithograph after a drawing by G. Pickering, printed by Engelmann. The aquaduct takes the Llangollen Canal over the valley of the river Dee. Like many lithographic views, this plate was printed in London but published locally, by J. Seacome of Chester.

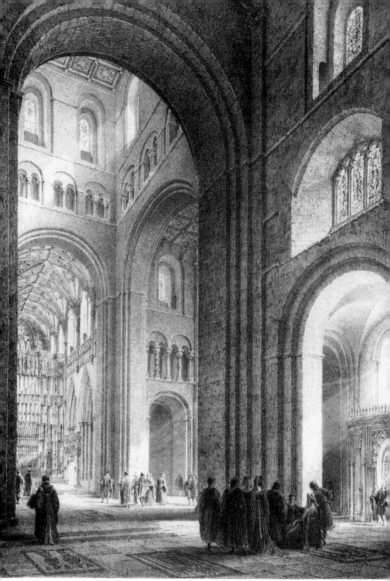

23. *Interior of St Albans Abbey Church: lithograph by Frederick Mackenzie, printed by Hullmandel. The plate is dedicated to the Earl of Verulam by Lewis Nockalls Cunningham, architect of the restoration of the cathedral.*

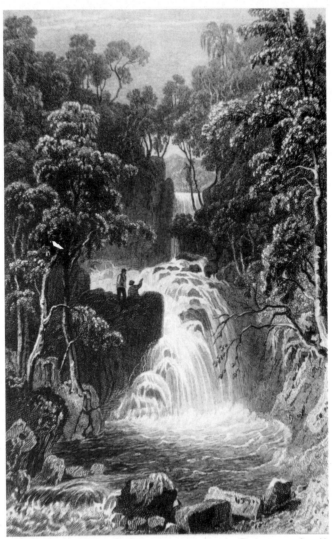

24. The Upper Fall at Rydal: steel engraving by T. Jeavons after H. Gastineau, first published in T. Rose's 'Westmorland, Cumberland, Durham and Northumberland Illustrated', 1832. Henry Gastineau was one of the last of the painters in the picturesque style.

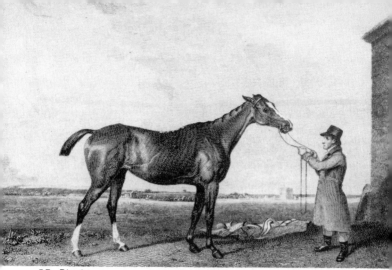

25. *Rhoda: copper engraving by William Smith after a painting by Abraham Cooper RA, 1821. Cooper became well known as an illustrator of horses for the 'Sporting Magazine'. In later life he was notable as a battle painter, his 'Battle of Marston Moor' being especially popular.*

26. *Fox Hunting: aquatint by Vivares and Merke after Samuel Howitt, from Howitt's 'British Field Sports', published by Edward Orme, 1807. This is perhaps the finest of all illustrated sporting books.*

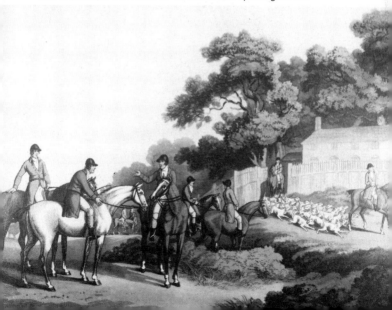

ted by Syd Edwards London Published Nov 1ˢᵗ 1805 by G Kearsley Fleet Street Engraved by F. San.

Nigella Damascena *Narcissus Jonquilla*
1 *Love in a mist. Devil in a bush.* 2 *Jonquill*

27. *Love in a mist and Jonquil, plate 37 from 'The New Botanic Garden', engraved by F. Sansom after paintings by Sydenham Edwards. The plate was published by Kearsley in 1805 and the collection appeared in two volumes in 1812.*

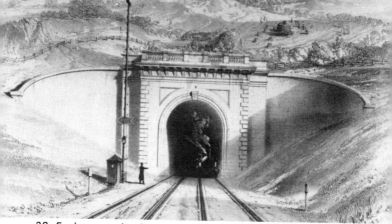

28. *Engine emerging from Box Tunnel: tinted lithograph from J. C. Bourne's 'History and Description of the Great Western Railway', 1846. Brunel's broad-gauge railway reflects the confidence of its engineer and shareholders in the monumental architecture of the tunnel portal.*

29. *Strolling Actresses Dressing in a Barn; copper etching engraving by and after William Hogarth, 1738. Hogarth's print was inspired by the Act against Strolling Players of 1737. The company of women and children (it was only actors who were forbidden to perform without a licence) are about to perform 'The Devil to Pay in Heaven', the character in the centre is rehearsing the role of Diana.*

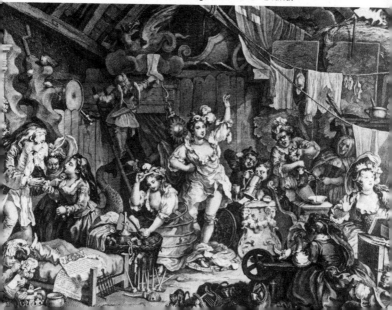

30. The Cock of the Rock on his Charger, 1790, one of many cartoons dealing with the siege of Gibraltar. General Sir Walter Elliot is riding 'a Spanish jack ass'. This anonymous etching was published by W. Holland, who claimed to have 'the largest collection of humorous prints in Europe' on exhibition.

31. Death or Liberty: coloured etching by George Cruikshank warning against the dangers of 'Radical Reform', published by G. Humphrey, 1819. Britannia is attacked by Death in the game of Liberty while the British Lion gallops to the rescue.

32. Doctor Syntax Pursued by a Bull, drawn and etched by Thomas Rowlandson: plate 8 of 'Dr Syntax in Search of the Picturesque', first published by Ackermann in 'The Poetical Magazine', 1810, with text by William Combe. Dr Syntax is a good-natured satire on the Reverend William Gilpin, well-known devotee of the picturesque.

33. Capture of the Liguria, August 7th, 1798: aquatint by T. Sutherland after a painting by T. Whitcombe, from James Jenkins's 'Naval Achievements', 1817. The Liguria, a Genoese pirate ship, was captured by the much smaller Espoir, a British brig-sloop, after a four-hour battle.

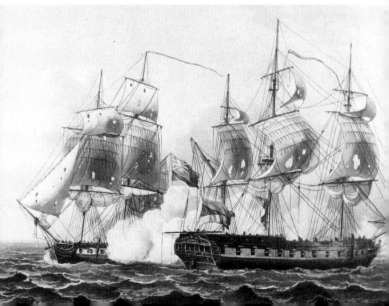

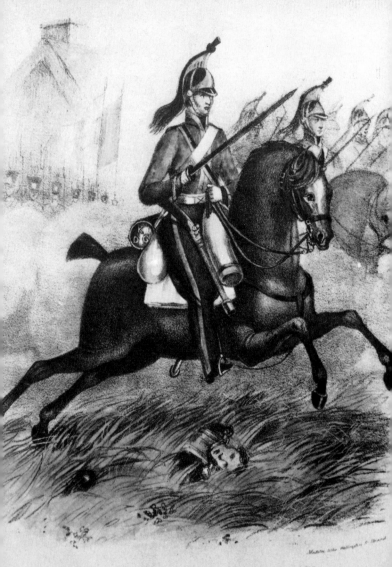

KINGS DRAGOON GUARDS 1815.

34. Soldier of the King's Dragoon Guards, 1815: lithograph by Madeley, from Cannon's 'Military History'.

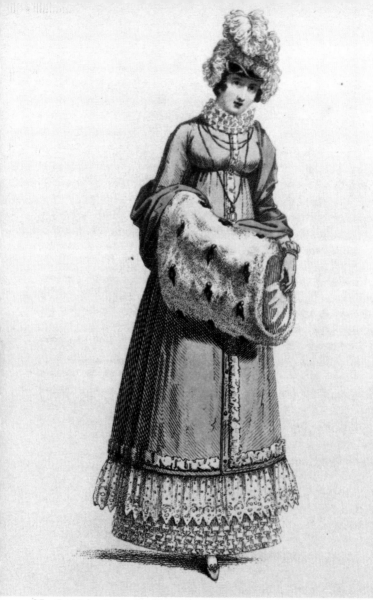

35. Fashion plate, Carriage Dress: aquatint from Ackermann's 'Repository of Arts', 1817.

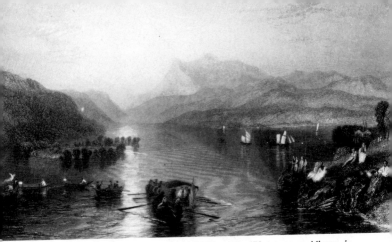

36. Winander Mere from J. M. W. Turner's 'Picturesque Views in England and Wales', engraved on copper by J. T. Willmore. Turner sketched Windermere in 1797 but his painting has little topographical relevance, being rather an artistic interpretation. In all, ninety-six engravings were made for the 'Picturesque Views', outstanding in both artistry and craftsmanship, forming perhaps the greatest collection of black and white studies after a single painter.

37. Near Holne, on the River Dart, from Frederic Christian Lewis's 'Scenery of the Devonshire Rivers', 1843. This is a mixed method plate, combining etching, aquatint and mezzotint. A member of a family of distinguished nineteenth-century artists, Lewis was well-known as both painter and engraver and a specialist on the rivers of Devon.

38. *The Skylark: etching by Samuel Palmer, 1850. The earliest of Palmer's major etchings, this illustrates two lines from Milton's 'L' Allegro': 'To hear the Lark begin his flight, And singing startle the dull night.'*

39. Reading the News: steel engraving by W. Taylor after the painting by Sir David Wilkie (1785-1841). The print is typical of the vast body of Victorian engraved work after popular oil paintings.

claims to be the best-known of all railway prints. These were sometimes sold with the T. T. Bury *Views*. Each plate shows two trains, passenger trains on the one and goods and cattle trains on the other, but there are many variations in the different issues. They provided the inspiration for David Gentleman's set of five commemorative postage stamps issued in March 1980.

Shaw also produced some fine black and white etchings, *Views of the Most Interesting Scenery on the Line of the Liverpool and Manchester Railway*. These included detailed studies of two locomotives, *Northumbrian* and *Planet*, and a dramatic view of Chat Moss, where the lines were laid on a floating embankment across five miles of bog. Shaw's confident handling of perspective and his control of the composition in this plate show him as perhaps the most talented artist in railway subjects.

It was the lithographers, however, who provided the majority of the early railway prints. D. O. Hill produced a set of *Views of the Opening of the Glasgow and Garnkirk Railway* in 1832 and Ackermann published *Six Views of the London and Greenwich Railway* by G. F. Bragg in 1836. A major undertaking, the London and Birmingham Railway, brought a set of aquatints after T. T. Bury in 1837 and, two years later, a splendid collection of lithographs by John Cooke Bourne. These originally appeared in four instalments, which were then published as a single volume with a text by John Britton: *Drawings of the London and Birmingham Railway,* with thirty-six plates. They showed the line and associated buildings under construction and provide a fascinating and invaluable record of early Victorian engineering at work. Only from Bourne's prints can we obtain a visual impression of the magnitude of the project and the disruption to both town and countryside that building the line caused, in particular from his plates showing the building of a retaining wall for the cutting at Camden Town and the excavation of the cutting at Tring. The London and Birmingham was also the subject of one of the best of the cheaper guides, Thomas Roscoe's *History of the London and Birmingham Railway,* 1839, illustrated by line engravings – pretty pictures, on the whole, lacking the accuracy and immediacy of Bourne.

In the next few years Bourne produced a few single lithographs of railway scenes. He became associated with Charles Cheffins, who, among other activities, was a railway architect and a publisher. Under Cheffins's direction Bourne produced a series of drawings of the Great Western Railway; these he lithographed himself and in 1846 they were published as *The History and Description of the Great Western Railway*. The collection comprises forty-six tinted lithographs, of which ten are views and details of churches near the route. The remainder give the most comprehensive record of an early railway at work. This was the

broad-gauge line of Isambard Kingdom Brunel, with its confident and massive bridges, viaducts and tunnels, and in John Cooke Bourne it found its appropriate memorialist.

Although none of them equalled Bourne, there were several other artist-lithographers of merit, including Edward Duncan, S. Russell, William Dawson, who illustrated the South Devon Atmospheric Railway, and A. F. Tait. *Views on the Manchester and Leeds Railway,* 1845, is Tait's best known work, but he also produced fifteen lithographs of the London and North Western Railway which were not published in volume form. These have greater interest as they give prominence to the railway itself, which, in the Manchester and Leeds collection, is often subordinated to the general landscape. Other good lithographs include 'The Railway at Swillington' by Henry Perry, 1841, T. M. Richardson's views of viaducts near Newcastle upon Tyne, Edwin Dolby's Birmingham and Gloucester Railway scenes and Alexander Scott's 'Viaduct over the River Medlock and Ashton Canal'. When the railway arrived in a town, the opening of the station was often commemorated in a locally published lithograph, but all these illustrations are becoming increasingly difficult to find. Among the rarest of all are three plates by W. W. Young and L. Haghe from an uncompleted series, *Illustrations of the Great Western and Bristol and Exeter Railways,* first published about 1835. These are hand-coloured lithographs and although they lack the precision of Hughes's aquatints after Shaw they equal them in attraction.

Many of the cheap railway guides, such as Osborne's, Freeling's and Roscoe's, included line engravings and woodcuts, though more often the views were of the scenery than of the railway itself. Osborne's *Guide to the Grand Junction* has a map and gradient profile of the line, with an engraving of the *Centaur* and train of five carriages, plans of Birmingham and Liverpool and a geological map as well as several plates and text illustrations, while Roscoe's *London and Birmingham Railway* describes the 'Home and Country Scenes on each side of the Line: including Sketches of Kenilworth, Leamington, Warwick, Guy's Cliff, Stratford &c...' and has sixteen engraved plates. Trains and stations at times appear in the local guide books, usually as incidental rather than principal illustrations. Accidents and disasters were pictured in woodcuts in the *Graphic* or *Illustrated London News.* Recently coloured prints from these publications can still be found and are considerably cheaper than the lithographs.

6. Natural history prints

Prints of flowers, birds, animals, insects and fish are popular with collectors and, as the great majority are coloured, are especially decorative. As with other categories of prints, however, information about them is not easy to come by. Of course, the great names – Redouté, Audubon, Gould – are widely known and their prints command very high prices. Even here, however, problems arise; not all the prints from Redouté's flower books were by Redouté himself, and if you are looking for an example of a particular artist's work you need to 'read' your print carefully and not accept a dealer's description at face value.

Most natural history prints originated as book illustrations, although frequently the text itself was of little significance. This sometimes causes confusion, as the book from which your print comes may be known by the name of the author or the name of the artist. You need to look carefully also for the country of origin; some of the finest natural history prints are German, French or Dutch and the fact that the flower, say, is familiar in Britain is no guarantee that it is a British print.

Until the advent of chromolithography, almost all British natural history prints were hand-coloured. In the eighteenth century the great majority were copper engravings. Towards the end of the century aquatints and mezzotints appeared, followed by lithographs, which eventually dominated the field. Stipple engraving was used in some of the great French prints, but seldom in Britain. Some smaller plates were colour-printed from woodblocks and there are a few examples of colour-printed copper engravings, although this method was more popular in France. Uncoloured natural history prints are likely to be early wood engravings.

Flower prints

Many of the flower prints came originally from periodicals which were intended to be bound up into volumes. The longest runner is the *Botanical Magazine,* begun by William Curtis in 1787 and still in being today, now published by the Royal Horticultural Society. In its earlier years this contained forty-six hand-coloured plates in each issue. The policy was to concentrate on the more exotic garden plants and it had a number of famous editors in its time. S. T. Edwards's publication, *The Botanical Register,* appeared between 1815 and 1847, its thirty-three volumes including an amazing total of 2,717 hand-coloured plates. Edwards himself was originally an illustrator for the *Magazine,* as was James Sowerby, whose thirty-six volume *English Botany,* with a five volume supplement, appeared between 1790 and 1834 with almost 2,800 plates, nearly all of

them after Sowerby's own drawings. Other similar publications of the period include *The Botanist's Repository,* ten volumes in all, with over six hundred plates after H. Andrews; *The Botanical Cabinet,* edited by Conrad Loddiges, 1817-33, twenty volumes, about two thousand plates; and *The Botanist,* by Benjamin Maund and John Stevens Henlow, 1837-42, with 250 plates.

One of the most attractive publications of the early nineteenth century was another William Curtis product, *The New Botanic Garden.* This appeared in two volumes in 1812 with sixty plates engraved by F. Sansom after the paintings of Sydenham Edwards. Two flowers are illustrated on each plate and the colouring and composition are very pleasing. The indefatigable Curtis was also responsible for *Lectures in Botany* in three volumes, again illustrated by Sansom after Edwards. If you are looking for pictures of onions or radishes, these are the prints to seek.

Details of the print runs of the botanical periodicals can be impressive: in the preface to the first volume of *The Floricultural Cabinet,* a monthly magazine edited by Joseph Harrison, gardener to Lord Wharncliffe of Wortley Hall, a circulation of nearly fifty thousand copies in the first nine months of issue is claimed. The plates from these magazines, cabinets, registers and repositories are generally carefully engraved and often finely coloured, although you will come across prints made from badly worn plates or where the colourist was hasty or slapdash. It is sad, however, that so many volumes have been destroyed for the sake of the plates; the texts themselves are often quite readable and the correspondence columns of *The Floricultural Cabinet* can be a delight.

The really splendid flower prints come from the large format volumes. Of these, the best-known is *The Temple of Flora,* which is strictly a section of a work entitled, less romantically, *New Illustration of the Sexual System of Linnaeus.* Edited by Dr Robert Thornton, it appeared in parts and in volume form in 1807. It was a commercial failure, ending with Thornton selling off unsold volumes and plates by lottery. Different artists were employed to paint the originals and the plates were colour-printed in aquatint, mezzotint and stipple, finished by hand. The book contains a ponderously scientific introduction, several pages of poetry, much of it fulsome and with a florid commentary, a remarkable number of copper-engraved titlepages and several engravings of Linnaeus in various postures. The flowers themselves, a miscellaneous collection ranging from common English garden flowers to strange confections from the Middle East, are painted against highly romantic backgrounds of supposed appropriateness; the church clock behind the Night Blooming Cereus shows midnight, the time when this flower is

said to bloom. This is one of the most impressive plates; another is Thornton's own Roses, engraved by Earlom in mezzotint, although the too obviously stuffed birds sitting in the foliage are not successful. The total effect, at first, is overpowering; the heavily worked plates lack the freshness of the less pretentious hand-coloured copper engravings, and Abraham Pether (known as 'Moonlight' Pether) is probably the only artist who has made snowdrops look menacing. Yet, taken singly, these are superb prints, the botanical equivalent of De Loutherbourg's *Romantic and Picturesque Scenery of England and Wales,* lacking the brilliance of the pure aquatint but with the added depth that mezzotint gives. There are thirty-four of them in all, and they can be found in a number of different states – though not very easily.

In his carefully researched study of natural history books, *Nature into Art,* Handasyde Buchanan finds only two English publications to compare with *The Temple of Flora.* The first is *The Beauties of Flora* by Samuel Curtis; this contains only ten plates, most of them also with backgrounds of landscape, by Clara Maria Pope. The other is the greatest of the fruit books, *Pomona Britannica*, by George Brookshaw, with ninety enormous aquatints of brightly coloured fruit. A less exotic but very attractive fruit collection is *Pomona Herefordiensis,* by Thomas Knight, confined to the homelier products of one English county. Plates from these volumes, especially the first three, or from such superb and specialised collections as John Sibthorp's *Flora Graeca,* with 966 plates after Ferdinand Bauer, or James Bateman's *The Orchidaceae of Mexico and Guatemala,* with forty hand-coloured lithographs compensating in size for the lack of number, are extremely rare and very costly.

The cheaper flower prints are mostly chromolithographs from the middle and later Victorian periods. Little books such as Jane Webb Loudon's *British Wild Flowers* of 1859, with sixty plates, or collections of 'Shakespeare's Flowers' or the flora of the Holy Land were both cheap and popular. Prints from such sources are often garish in colouring; to produce chromolithographs of quality was a skilled and expensive business inappropriate to this particular market. If you have not seen the earlier hand-coloured copper engravings or aquatints the chromolithographs may at first attract you, but comparison will soon give perspective to your judgement. Today's good colour photography excels the chromolithographs in every respect but cannot equal the delicacy and sensitivity of the best flower prints of the early nineteenth century.

Bird prints

Of the remaining natural history prints, those depicting birds must take priority. Here the names of Audubon and Gould are

dominant, both for the quality of their prints and the prices they command. John James Audubon was American-born and his greatest achievement was *The Birds of America,* but this was produced in England and nearly all its 435 hand-coloured aquatints were by Robert Havell. These enormous plates, about 40 by 30 inches (1016 by 762 mm), show the birds life-size and set against an appropriate landscape or foliage background. They appear occasionally at auctions but generally they have been made familiar through later reproductions. John Gould's plates – there were three thousand of them in all – are hand-coloured lithographs and cover Europe, Great Britain, Australia, Asia, New Guinea and the Himalayas. Henry Richter collaborated with him in some of his publications and Charles Hullmandel was his printer. Brilliantly coloured and carefully printed, Gould's prints are always in demand.

Other major collections of bird plates include two mighty volumes illustrating birds of paradise, one by Bowdler Sharpe and the other by Daniel Gould (the latter was published in New York). These were hand-coloured lithographs, as were the much earlier plates by Edward Lear for *Illustrations of the Family of Psittacidae or Parrots,* with forty-two prints, published 1830-2. Lear, one of the greatest of bird artists, worked on some of Gould's earlier publications, including the *Toucans* and *Birds of Europe.*

It was the technique of lithography that enabled these very large plates to be made: Lear's *Parrots* were 21 by 14 inches (533 by 356 mm). The earlier prints were generally intended to be bound up in octavo or, at most, quarto. Two comprehensive collections are John Lewin's *Birds of Great Britain,* completed in 1801, with a total of 336 plates, including fifty-nine of eggs, and E. Donovan's *The Natural History of British Birds*, with 244 plates, 1799-1819. In the mid nineteenth century the Reverend F. O. Morris produced his *History of British Birds* with 358 plates, one of the last of this type of publication with hand-coloured illustrations. A few years later chromolithography took over almost exclusively, as with the flower prints.

When he was a young man, Audubon, creator of the largest prints of birds, visited and paid tribute to Thomas Bewick, whose *History of British Birds* the American greatly admired. Bewick's work is readily accessible; indeed, later reproductions of his wood engravings may often be more satisfactory than the early editions, where the paper was usually of poor quality. The birds themselves are accurately observed and so assured is the engraving technique that one is scarcely aware of it. Audubon described his work as 'exquisite'; most exquisite of all his engravings, however, are the famous tailpieces to the sections in the *Birds* in which a whole rural world can be found. Birds and

Fig. 6. 'Brent Goose', a wood engraving by Thomas Bewick, cut in 1801 and published in Volume II of 'A History of British Birds', 1804.

tailpieces combine to make the *History of British Birds* (which originally appeared in two parts as *Land Birds* and *Water Birds*) one of the most fascinating of all the natural history illustrated books and one of the very few that the non-ornithologist can wholly appreciate in black and white.

Other creatures

Mammals, insects and fish have proved less inspiring to printmakers than birds and where the whole animal creation is covered in a single publication the birds generally are dominant. In two of the more important eighteenth-century collections, *A Natural History* by George Edwards and *The British Zoology* by Thomas Pennant, between them spanning the years 1743 to 1766, there are more plates of birds than of any other type of creature. Audubon's *The Viviparous Quadrupeds of North America,* first issued with folio plates and later with large octavo, consisted of hand-coloured lithographs, with much of the work done by his sons and by John Bachman. The plates are very fine but lack the vigour and excitement of the *Birds.* British animals are well served in *The Breeds of the Domestic Animals of the British Isles* by David Low, 1842. The large single print by Bewick, 'The Chillingham Bull', is a fine piece of work but has an artificiality about it notably absent from the best of his smaller engravings. A few excellent hand-coloured lithographs of animals after paintings by Edward Lear and many more after B. Waterhouse Hawkins appeared in *Gleanings from the Menagerie and Aviary of Knowsley Hall* by John Edward Gray, 1846-50.

An eighteenth-century specialist in butterflies was Moses Harris; *The Aurelian,* with forty-one hand-coloured copper engravings, is an outstanding work. Other insect prints of that century were produced by Benjamin Wilkes and Dru Drury, while the early nineteenth century saw publications by John Lewin and Edward Donovan's *Insects of India.* Perhaps the best prints of fish come from *British Freshwater Fishes* by William Houghton, especially interesting to collectors as, in an age of lithography, the large plates are coloured wood engravings by Benjamin Fawcett. Thomas Bewick began a *History of British Fishes* but no more than sixteen examples were completed. One of his apprentices, Henry White, contributed some of the wood engravings to William Yarrell's two volumes with the same title published in 1836.

On a different scale from most natural history print collections in almost every respect was *The Naturalist's Library* of forty volumes, edited by Sir William Jardine and published between 1833 and 1843. These little books contained a total of over 1,300 plates. The quality, as might be expected, is variable between volumes, with a large number of artists and engravers being employed in the undertaking. The *Library* is typical of the thoroughness of its period, however, and is both informative and attractive. Single volumes, each including about thirty plates, can still be found, although like so many natural history books they are ready prey for the 'breakers'.

7. Moralities and caricatures

William Hogarth

In the eighteenth and early nineteenth centuries a number of artists used prints to convey statements or points of view to the widest possible audience in the cheapest possible way. First and most important of these was William Hogarth, a great painter who was also, in his own characteristic way, a moralist expressing through graphic art situations and stories that parallel the prose fictions of Defoe and Fielding. Between 1721 and his death in 1764 he issued more than 250 plates, many of them etched and engraved by himself. Best known are the story-telling sets:*The Harlot's Progress, The Rake's Progress, Marriage à la Mode, Industry and Idleness,* the *Four Prints of an Election* and *The Four Stages of Cruelty.* Hogarth described his picture as his stage, and men and women as his actors, and each print in a set epitomises an act in a play, related to what has preceded and what follows. To take *The Rake's Progress* as an example, the story is summarised by the titles of the eight plates: first 'The Young Heir Takes Possession of the Miser's Effects'; this is followed by Tom

Rakewell, the young heir, seen 'Surrounded by Artists and Professors' who are trying to extort money from him – many of them are recognisable characters of the day. 'The Tavern Scene' shows Tom drunk and debauched; in the next plate he is 'Arrested for Debt'. To re-establish his fortunes he is 'Married to an Old Maid'; then we witness him losing his gains in 'Scene in a Gaming House'. He is arrested for debt and sent to the Fleet, as we see in 'The Prison Scene'; this is not, however, the end. 'Scene in a Madhouse' shows Tom in Bedlam with only one sympathiser, Sarah Young, whom he seduced before he first came into a fortune as we saw in the first plate and who also appeared in distress in two other plates. Like so many other plates by Hogarth, *The Rake's Progress* can be read almost as one reads a book; the prints are full of activity and everything that happens is a comment on the main theme.

Hogarth also used prints to express a political or social argument. In support of the Gin Act, intended to control the hitherto unlimited sale of gin, he produced a set of two prints, 'Beer Street' and 'Gin Lane'. The first shows happy Londoners enjoying their foaming tankards outside the Barley Mow. Life goes busily along, there is a general air of prosperity and the only sign of poverty is the crumbling house of the pawnbroker. But on a ladder stands a French signwriter adding an advertisement for gin to the sign of the Barley Mow.

In 'Gin Lane' all has changed. The pawnbroker flourishes; his house has been rebuilt with a gin cellar beneath it bearing the legend 'Drunk for a Penny; Dead Drunk for Twopence: Clean Straw for Nothing', above its door. Other buildings, apart from a distillery, are falling down; in one a barber has hanged himself as now he has no customers. The streets are full of angry drunkards; the corpse of a woman is being placed in a coffin; a beggar shares a bone with a dog. In the centre a drunk and diseased mother lolls on the steps while the baby falls from her breast to death on the cobbles below.

It would be wrong to assume that Hogarth is always pointing a moral or conducting an argument. In the engraving 'Strolling Actresses Dressing in a Barn', described by Horace Walpole as 'for wit and imagination...the best of all his works', he shows a company of women and children preparing to perform *The Devil to Pay in Heaven*. There are no men because the 1737 Act against strolling players forbade actors performing outside London unless a licence had been obtained. As a composition the plate is extraordinary; in the centre half-dressed Diana rehearses a speech while around her action involving actresses, children and properties covers every inch of the surface. Yet there is an underlying irony, depending on the contrast between the actresses themselves and the parts – Juno, Cupid, Ganymede, Night, a

Ghost – they play. The irony is emphasised by the uses to which the properties are being put: an altar is used as a table for tankards and a pipe, a monkey urinates into Jupiter's helmet, and a state crown, with a baby's feeding ladle on top of it, stands next to a chamber pot. It looks as if at any moment the barn will go up in flames; a candle has already set a props basket alight and a smoking pipe is about to fall into the rushes. Through a hole in the roof a peeping Tom observes all.

It was Hogarth who was mainly instrumental in obtaining the Copyright Act of 1735, which made the copying of prints illegal for a period of fourteen years after issue and ensured that the original artist and printmaker were not robbed of their profits – as had happened to Hogarth himself with *The Harlot's Progress,* published in 1732 and copied wholesale. Good early issues of Hogarth's prints can be found in the salerooms, but anything cheap is likely to be a reissue and your money might better be spent on a modern collection of the engravings with a commentary to add to your understanding and enjoyment. With his delight in human activity, his keen satirical sense and his technical accomplishment William Hogarth is one of Britain's greatest artists. It is through his engravings that his work has become so widely known and they are among the most important of his achievements.

James Gillray

In no sense can Hogarth be described as a caricaturist. In some ways, however, with plates such as the *Four Prints of an Election* or the two plates of *The Invasion* he points the direction for the two great caricaturists that followed: Thomas Rowlandson and James Gillray. Caricature was only a part of Rowlandson's work but it was the whole of Gillray's, who in this realm dominated his contemporaries and stands among the greatest. For nearly twenty years Gillray's coloured etchings were in keen demand, nearly all of them published and sold by Mrs H. Humphrey, in whose premises he lodged. Among his earlier prints was an attack on John Boydell, who had not commissioned him to contribute to the *Shakespeare Gallery;* Gillray's 'Shakespeare Sacrificed – or – The Offering to Avarice' shows far greater imaginative conception than anything in the *Gallery* itself.

Gillray seemed to fear no one; among his targets were George III, the Prince of Wales and the leading politicians of the time, especially Charles James Fox. His 'Promised Horrors of the French Invasion', a coloured etching with aquatint, in its activity and the complexity of the narrative rivals the 'March to Finchley' or the 'Strolling Actresses' of Hogarth. Perhaps more characteristic are the prints that concentrate on one or two readily recognisable figures, such as 'The Plumb-Pudding in Danger – or

– State Epicures Taking un Petit Souper', which shows a manic miniature Napoleon and a somewhat raddled Pitt seated at table and carving up the world with swords and forks. Some of the later plates show a fantastic, almost surreal imagination; two remarkable specimens that passed through the salerooms recently are 'Ci-devant Occupations – or – Madame Talian and the Empress Josephine Dancing Naked Before Barrass in the Winter of 1797 – a Fact', with a tiny Napoleon peeping through a curtain at the naked beauties whirling around behind a filmy gauze while the half-drunk lecherous Barrass slumps in an armchair looking on, and 'Political Mathematicians, shaking the Broad-Bottom'd Hemispheres', a print that makes Salvador Dali's imaginings seem tame.

What is special about Gillray is the urgency of his line; he is said often to have etched directly on to the copperplate without making any preliminary drawing and to have worked furiously until his fingers bled. Mrs Humphrey's colourists also served him well. His prints retained their popularity well into the nineteenth century, although in 1810 he became insane and was able to work no more, dying five years later.

Thomas Rowlandson

Gillray outshone all his contemporary caricaturists – Henry Bunbury, William Heath, Charles Williams, Robert Dighton — except for Rowlandson. Unlike Gillray's, however, Rowlandson's work was not confined to the world of the satirical cartoon; he was one of the finest watercolour painters, adept at portraying urban bustle or rural tranquillity and letting these pictures speak for themselves with no moral or satirical comment. This aspect of his art can be seen in the print by Francis Jukes and Pollard of his watercolour of Vauxhall Gardens, exhibited in the Royal Academy in 1784. His study of George Morland, made about 1785, is one of the most attractive of English portraits.

There is a large number of Rowlandson satirical prints, mostly coloured etchings, with similar subject matter to Gillray's. Many of them are anti-Napoleon broadsides with titles like 'Boney the Second or the Little Baboon Created to Devour French Monkies' or 'Nap and his Friends in their Glory'. But his characteristic qualities of humorous observation expressed in flowing line are better shown in prints such as 'A Field Day in Hyde Park', aquatinted by Thomas Malton, his various sporting scenes or his 'Characteristic Sketches of the Lower Orders'. Best known of all are his coloured etchings for the three 'Tours' of Dr Syntax by William Combe, published by Rudolph Ackermann. The first – and best – of these, *Tour of Dr Syntax in Search of the Picturesque,* 1812, was a good-tempered parody of the countrywide

tours of the Reverend William Gilpin, whose many publications, illustrated by aquatints after his own interpretations of picturesque scenery, were widely known. In his search, Dr Syntax undergoes all manner of undignified adventures from which he emerges undismayed to continue his pursuit. 'Dr Syntax Pursued by a Bull' shows Rowlandson's ability to capture movement with economy of line, while his 'Dr Syntax Sketching the Lake', oblivious to the fact that his greedy horse is likely to tip him into it at any moment, is the neatest of satires on the picturesque obsession. In some of his own drawings Rowlandson shows an awareness of the picturesque possibilities in landscape but he never allows this to falsify his observation. Again he has his own comment on the travelling artists who sought picturesque subjects in remote parts of the countryside; his 'An Artist Travelling in Wales', a coloured aquatint of 1799, shows one such astride a scruffy nag, burdened with palette, easel, sketchbook, coffee pot and other impedimenta, protecting himself from the downpour with an inadequate umbrella, descending a steep hillside towards a church in the wooded valley below and ignoring the poor mother and children standing nearby.

Ackermann employed Rowlandson as an illustrator for several of his colour publications. In the plates of *The Microcosm of London* he drew the figures while Augustus Pugin drew the buildings: the plate of the 'Water Engine at Coldbath Fields' is a good example. Among other splendid work is a set of twelve aquatints of Oxford and Cambridge, published between 1809 and 1811. Rowlandson took special pleasure in depicting plump people, like overfed dons or ladies with large thighs such as those falling about in the *Exhibition Stare-Case* print of about the same time. He also produced one of the finest sets of military costume prints: the *Loyal Volunteers*, published in 1799.

Good issues of Rowlandson prints tend to be costly, some of the large and rare ones running into hundreds of pounds. Plates from the coloured books may still be obtained for a reasonable price, especially of the less fashionable – but sometimes more interesting – subjects. Dr Syntax and *Dance of Death* plates can be found without much difficulty, but these were popular books and ran into many editions. Be wary of plates that are garishly coloured; they are mid-Victorian reissues and show up poorly when set beside good specimens of the early editions. Similarly with the political caricatures, those with the imprint of Fores or Humphrey are almost always better in all respects than those published by Thomas Tegg.

George Cruikshank

In caricature, George Cruikshank took over from Gillray and Rowlandson as the leading exponent for many years. His father,

Isaac, was a caricaturist of note but he died about the time that Gillray became insane. George, not yet twenty years old, was employed by Mrs Humphrey to complete some of Gillray's plates and he continued the anti-Napoleon campaign until the battle of Waterloo. Between his and Gillray's work there is little to choose; Cruikshank shows a similar vigour in attack but his imaginative leaps are less stupendous than his master's, which is not surprising as it would seem that Cruikshank, on the whole, was thinking as he was told. In 1820, he was told something else in a rather different way; with his brother Robert he was given £100 for an undertaking not to draw the newly crowned George IV doing anything naughty. Cruikshank's cartoons of 'Prinny', especially with regard to the ill-treated Caroline, were both savage and hilarious, but the 1820 etching of the new king confronting the radicals, in the guise of 'Coriolanus Addressing the Plebians' shows a very different attitude.

About this time Cruikshank turned to book illustration. Together with his brother he produced the aquatints for Pierce Egan's *Life in London* and he went on in succeeding years to provide etchings and wood engravings for a large number of books and periodicals. He illustrated *The Comic Almanack* for nineteen years, producing almost two hundred full-page plates and innumerable wood engravings. Here, and in other publications such as *Scraps and Sketches,* he was able to express his own thoughts and feelings through his work; he emerges as a generous-minded reformer, with some similarities in attitude to Charles Dickens. An especially telling print was published against the proposed enclosure of Hampstead Heath; the trees, shrubs and animals are being attacked by an army of bricklayers' tools supported by rows of advancing houses – all called 'New Street' – and a bombardment of bricks from a kiln.

Among the books Cruikshank illustrated were novels by Fielding, Smollett, Scott and Harrison Ainsworth. For a few years he worked with Dickens, illustrating *Sketches by Boz* and *Oliver Twist,* but Dickens deserted him for Hablot Brown despite his splendid recreations of Fagin and Bill Sykes. Other work included powerful etchings for *The History of the Irish Rebellion* by W. H. Maxwell, 1845, and comic ones for *The Greatest Plague in Life* by the Mayhew brothers, an amiable satire on the domestic servant problem.

In later years Cruikshank became a dedicated teetotaller. He published in 1847 a set of eight glyphographs entitled *The Bottle,* depicting, like a mid Victorian Hogarth, the effects of drink on a respectable family, following this with another set of eight, *The Drunkard's Children.* The last of these, showing the daughter, with her father and brother both dead, flinging herself off a bridge into the Thames, is a starkly powerful work. He continued

to produce illustrations to all types of books until his death in 1878. Books illustrated by Cruikshank are well worth seeking out but, although he was one of the great printmakers of the nineteenth century, they should be treated as books, not broken for the sake of the illustrations.

8. Military, maritime and costume prints

Military prints

According to the *Index to British Military Costume Prints*, over fifteen thousand plates depicting military uniforms were issued between 1500 and 1914. Mostly they were published in sets or series, printed in black and white and hand-coloured for display and when ordered for purchase. They generally show single figures or small groups, with the emphasis on the details of the uniform and accoutrements, but some series show troops in action. Examples of these are Robert Bowyer's coloured aquatints of Waterloo and various campaigns in the Napoleonic Wars, Jenkins's *Martial Achievements,* with fifty-three aquatints, and Richard Westall's twelve scenes of the victories of the Duke of Wellington.

Of the prints concentrating on figures rather than battle scenes the earliest major collection is *The Cloathing Book,* with 102 engravings by John Pine, first published in 1742, while probably the most outstanding set is Rowlandson's *Loyal Volunteers* of 1799. Most of the more attractive series were published between the end of the eighteenth century and the middle of the nineteenth over the imprints of four main publishers: Heath, Fores, Ackermann and Spooner. In the later years of this period some good lithographs appeared, including the illustrations to Cannon's *Military History* and the well known set of W. Simpson's *The Seat of War in the East,* eighty tinted lithographs illustrating events in the Crimean War. Hand-colouring this type of work, with several of the plates showing many hundreds of soldiers in a variety of uniforms, was a massive undertaking, especially as many well informed eyes were ready to spot any inaccuracy. Many of the Simpson lithographs are still easily obtainable, except for the one showing Florence Nightingale ministering to the wounded, which has become very rare. Cheap hand-coloured steel engravings can also be found, with the likelihood that the colouring dates from the issue of the print and has not, as is usual with steel engravings, been added only recently.

Maritime prints

For maritime prints, including both naval and merchant

shipping, aquatint was a popular medium. James Jenkins's *Naval Achievements*, covering the period 1793-1817 and issued in the latter year, and the *Liber Nauticus* after Dominic and John Thomas Serres, 1805-6, are two of the finer collections, containing fifty-seven and forty-one plates respectively. As well as the Serres family, specialist marine painters of the period included Robert Dodd, for whom Francis Jukes engraved some splendid scenes, Thomas Whitcombe, well represented in Jenkins's publication, and William John Huggins, whose paintings were engraved by Edward Duncan. An exceptionally good early set is *The Return of Rear-Admiral Graves's Fleet from the North American Station and its Destruction by a Hurricane*, four coloured aquatints by Jukes after Dodd.

Some fine large coloured lithographs were published in the mid 1850s entitled *The English and French Fleets in the Baltic*, many of them by T. G. Dutton after paintings by Sir Oswald Thomas Brierly. Another set, by W. Simpson, *A Series of Eight Sketches in Colour of the Voyage of HMS Investigator,* appeared about the same time. The painter of these, Lieutenant Samuel G. Cresswell, was, like Brierly, an active seaman, and these prints carry conviction of their accuracy.

There are also several good maritime etchings to be found. Nicholas Pocock, a leading marine painter in watercolour, made a number of black and white outline etchings of ships of war, following them with half a dozen more of coastal and Thames vessels, including the Prince Regent's yacht. Samuel Prout etched a number of plates of fishing craft, using the soft-ground technique. Possibly finest of all is Edward William Cooke's *Shipping and Craft,* a collection of etchings made over a number of years and published in one volume in 1829.

Maritime prints of quality, like early impressions of good sporting prints, are rare and costly. Some fine views of shipping, however, can be found among the aquatints from Daniell's *Voyage Round Great Britain*. 'Seacombe Ferry, Liverpool' is one good example, and 'Steam Boat on the Clyde near Dumbarton', published in 1817, is said to give the first pictorial representation of such a vessel. Also in aquatint are Samuel Owen's plates of the tideway in his and William Westall's *Picturesque Tour of the Thames*. A number of excellent copper engravings after Owen, also of the tideway, were published in *Scenery of the Thames* by the brothers W. B. and G. Cooke.

Maritime scenes were also steel-engraved and you may be able to find specimens that have not been recently hand-coloured. Among the best of these are the prints from Clarkson Stanfield's *Coast Scenery,* 1836, and the engravings from Finden's *Ports and Harbours,* the first and better volume of which appeared in the same year. J. Cousen's engraving of Stanfield's 'Falmouth' and

E. Finden's engraving of E. W. Cooke's 'Men of War at Spithead' are two of the finest maritime prints ever made.

Costume prints

Costume prints are very collectable. Three fine series date from the early nineteenth century. The first to be published was *A Picturesque Representation of the Naval, Military and Miscellaneous Costumes of Great Britain,* with thirty-three coloured plates in soft-ground etching with aquatint, by J. A. Atkinson, 1807. In the following year William Pyne's *The Costume of Great Britain,* with sixty coloured aquatints, appeared. This showed individuals at work with their equipment or appropriate vehicles, ranging from a watering cart to the Lord Mayor's state coach. George Walker's *The Costume of Yorkshire,* with forty aquatints by the Havell brothers, was published in 1814. Of the many collections of regional costumes this is the best, the Havells' aquatints being of the highest quality. Today it is difficult to visualise a market for this sort of collection of illustrations, but for Walker's volume a continental sale was planned as the text is in both English and French. The plates show 'clothmakers, colliers, fishermen, farmers, spinners, knitters, cutlers' and there are four military uniform plates. The well known print of the collier shows in the background the first illustration of a steam engine on rails; this was built in Leeds and used to haul coals from 1812 until 1833. It is worth nothing that a facsimile edition was issued in 1885 with markedly inferior colouring.

Several sets of prints depicting costumes of foreign countries were published, many of them by Rudolf Ackermann. Attractive examples of costume prints also appeared in Ackermann's *Repository* and these are not difficult to find. Some of these can be described as fashion prints, but a few years later most of the fashion plates in circulation were imported from France, the best of them coloured lithographs after the drawings of Jules David. The English ladies' magazines commonly used French plates after David or one of his successors.

9. Decorative prints: mezzotints and stipple engravings

It was chiefly through the media of mezzotint and stipple engraving that the work of the painters of the second half of the eighteenth century became widely known. The portraits, groups and subject paintings of Sir Joshua Reynolds, George Romney, John Hoppner, William Hamilton, James Ward and others, mostly Royal Academicians, were translated into prints by expert

craftsmen including James MacArdell (a Reynolds specialist), John Raphael Smith, Valentine Green, James Walker, William Ward and Thomas Watson. It was all good for trade; whether it was particularly good for art is another matter. Among the most successful mezzotints were William Pether's plates after Joseph Wright of Derby. Wright was deeply occupied with the effects of artificial light and mezzotint was the ideal medium for the translation of these effects. These prints are far more compelling than the mezzotints after the portraitists, but the reason lies with the vision and originality of the painter rather than with the skill of the makers of the prints.

Nevertheless, in their time these mezzotints were enormously popular and the best of them translated their coloured originals into black and white as honestly as possible. At times they have been in great demand by collectors, but as tastes have changed they have lost ground to the aquatints in recent decades and are now sought by comparatively few. It depends greatly on how you regard the painters of the originals, most of whom you may think are not among the more original or interesting figures in the history of art in Britain.

Good quality mezzotints are rare as the plates wore quickly, allowing only three or four dozen impressions to be made before deterioration became obvious. Three sets of mezzotints, however, have been of major importance in the history and development of British art and plates from these sets are well worth seeking. The first is the set of two hundred mezzotints with etched line by Richard Earlom after the paintings of Claude: the *Liber Veritatis,* published by Boydell in 1774-7. Through these plates, unexciting though they may seem today, knowledge of Claude's work was widely circulated and his influence on British painting was extended. The *Liber* was taken as a model by J. M. W. Turner some thirty years later in his *Liber Studiorum,* intended as a compendium of landscape subjects and styles. For the seventy-one plates Turner employed several engravers, also working on some himself. For all the plates, he etched the outlines himself and often it is the firm structure of the composition that is its most outstanding quality. Turner also used mezzotint for *River Scenery* and the *Little Liber*.

The third set is the *English Landscape* series by David Lucas after the paintings of John Constable, which appeared in parts in the early 1830s with Constable's own descriptive text. This was Constable's only attempt to make his work more widely known but it was not a financial success. In his lifetime Constable was never a popular painter and Lucas made no fortune, dying in a workhouse in 1881. But the plates are perhaps the greatest of landscape mezzotints. They were made for the most part from small oil sketches, although some larger pictures were also used,

and Constable kept a careful watch on the progress of the proofs, criticising and amending until he was satisfied. As a printmaker, Lucas was no genius; but it seems that the pressure and persistence of Constable, with an occasional word of praise, enabled him to produce work of a quality beyond his natural ability. He continued to produce plates from Constable's paintings after the artist's death and also made several mezzotints after paintings not included in the *English Landscape Scenery* series. The large plate of 'Salisbury Cathedral', not published until 1848, has been described as 'the greatest *tour de force* ever brought off in mezzotint'; other especially fine plates include 'Spring', said to be Constable's favourite, 'Lock on the Stour' and 'Summer Morning'. Good impressions of these mezzotints, however, are very rare; the 1855 reprints are poor as the plates were heavily worked and greatly worn. They should be examined in a gallery or museum if you wish to see the full capacity of mezzotint for expressing landscape when both painter and engraver work together.

Coloured mezzotints are sometimes considered a contradiction in terms, though not all mezzotints were printed in colour to disguise the wear on the plate. Like coloured stipple engravings, they tend to prettify the subject; many of them are the period's equivalent of the bland photographic prints of, say, Van Gogh, where the violent handling of the paint and the sheer tension of the work disappear completely in the glossy reproduction. A careful examination by Dr John Barrell (*The Dark Side of the Landscape,* 1980) has shown how the engravers after George Morland, a most prolific and popular painter, often falsified details, taking the edge, as it were, off his statement: a woebegone expression becomes a happy smile, the harsh face of poverty is smoothed over. In most of the paintings that were engraved, however, there was no edge to be taken off; the bland, sentimental or mildly pornographic original produced a print likewise. For an example of each try to see Keating's coloured stipple of 'The School Door' and 'The Cottage Door' by Francis Wheatley, Dayes's coloured mezzotint of J. R. Smith's 'A Visit to the Grandfather' and William Ward's coloured mezzotint of Joshua Reynolds's 'The Snake in the Grass'.

Of all these coloured prints the most popular have always been Francis Wheatley's *Cries of London*. These thirteen plates were engraved in stipple in 1794 by three foreign craftsmen: Schiavonetti, Gaugain and Cardon (like the first of these, the best known stipple engraver of all, Bartolozzi, came from Italy). These prints have been reissued, lithographed, photographed and reproduced a countless number of times. As far as market values are concerned, almost all these issues are worthless. Very seldom indeed does a first edition ever emerge and identification of one is

a matter for a specialist. Yet Wheatley's *Cries* are no more than bits of sentimentalised decoration; in the London of the real observers, Hogarth and Rowlandson, his girls would not have lasted thirty seconds. Compare his 'Do you want any Matches?' with J. T. Smith's economic and truthful etching of a matchseller made a few years later. The comparison makes a revealing comment on the print dealers' view of popular taste in 'art'.

Several engravers combined mezzotint with other methods of printmaking, producing plates of rich texture and variety. The plates in Thornton's *The Temple of Flora,* printed and hand-finished in colour, are supreme examples of what can be done by working mezzotint and aquatint together. In black and white, the prints of George Stubbs are outstanding. He began by etching and engraving his own *Anatomy of the Horse* drawings in 1766 and later translated several of his own paintings into prints made by combining mezzotint with other printmaking techniques. All Stubbs's art compels by its honesty and his prints make no concessions to public taste. Some years later another painter, Frederic Christian Lewis, published a number of collections of prints made by himself from his own paintings. Lewis used etching, aquatint and mezzotint, both separately and combined as in his *Scenery of the Devonshire Rivers* series, published in 1843. As a painter, Lewis was a recorder rather than an interpreter but his handling of the mixed method in his printmaking gives the plates a variety of texture that makes them more interesting than the paintings themselves.

Little pure mezzotint work of quality was produced after about 1820; the technique was not suited to the steel plates which came rapidly into widespread use. F. C. Lewis and David Lucas both worked on copper but this had become a comparatively expensive method compared to the lithograph and steel engraving. Lewis was one of the last artists of any note to use the technique at all.

10. Artists' etchings

The etching process is often used in conjunction with engraving in reproductive prints but the 'true' etching is in a creative class of its own. The plate itself is the work of the artist or designer of the picture who draws with his needle directly on to the waxed ground covering the metal plate. Etchings, therefore, may convey a feeling of spontaneity which engravings usually lack and their success also owes a great deal to the care and skill of the printer.

Etching in Britain has a peculiar history. From the sixteenth to the eighteenth centuries it was virtually ignored, except as an adjunct to engraving. Meanwhile on the continent of Europe the method flourished, with many of the greatest artists –

Rembrandt, Tiepolo, Canaletto, Piranesi, Goya – producing work of outstanding quality and importance. In Britain only Wenceslaus Hollar was of more than local significance. Many of his plates are copies of drawings by others but his original work combines sensitivity with accuracy though it lacks the vision and scale of the greatest masters. Hollar's etchings are not difficult to find and the small plates are still moderately priced.

Perhaps the only two English-born etchers of the late seventeenth century whose work is of much interest are Francis Barlow and Francis Place, both of whom knew and were influenced by Hollar. Barlow's speciality was animals; he was one of the earliest sporting painters and produced possibly the first print of a horse race in 1687. Place, who according to Samuel Redgrave 'amused himself with art', was a busy and skilled etcher and mezzotinter whose wide range of subjects indicates an active mind and whose career would repay research.

No etching school or tradition developed in Britain during the eighteenth century. Hogarth used the method for the groundwork of many of his line engravings and also published some etched 'subscription plates' as a means of attracting interest to his more ambitious works. Among Paul Sandby's early work are several etchings, including satirical studies and landscapes, and Gainsborough produced a handful of etchings in soft ground. Practitioners of lesser note include the brothers George and John Smith of Chichester and the Scotsman John Clerk. By far the most vigorous work, however, was in the realm of satire, especially political, dominated by Rowlandson, Gillray and George Cruikshank, and this has already been described.

In the early nineteenth century a remarkable group of artists was at work in East Anglia. The paintings of the 'Norwich School' are well known; less known are the etchings of these painters, yet many of them are superb. Good impressions of many of them can still be found, although care is needed with the etchings of John Crome. This great painter produced thirty-four plates in all, mostly of trees and intimate corners of landscape. They were not published during his lifetime but thirty-one of them appeared in 1834 entitled *Norfolk Picturesque Scenery* in an edition of sixty sets. Presumably because they sold slowly, Crome's patron, Dawson Turner, had the plates 'improved' and reissued; the improvements, aimed at producing a more finished-looking article, were disastrous. Only the few soft-ground etchings remained unaltered and impressions of these are scarce.

For Crome's contemporary John Sell Cotman etching was a major activity and he produced nearly four hundred plates. Many of them are architectural subjects from Norfolk and Normandy, finely executed but perhaps of limited appeal. A collection of mainly soft-ground etchings, *Liber Studiorum,* contains some of

his most interesting work. Robert Dixon, Joseph Stannard, John Middleton and Henry Ninham were among other Norwich painters who produced etchings of quality; Middleton's in particular are worth seeking out.

West Country painters of the early nineteenth century whose etchings are collectable include Samuel Prout, T. H. Williams, William Payne and F. C. Lewis, who chose the area for his work although he was not born there. Prout favoured the soft-ground technique, while Lewis's studies of the riverside scenery of the Tamar, Tavy and Exe are delicately observed. Other etchers concentrated on antiquities and ruins and many acres of waxed copper were ploughed through to record the details of cathedrals and abbeys. Exceptional among these was John Thomas Smith, whose etchings of London antiquities are enlivened by portrayals of well known street characters of the time. His *Vagabondiana* is a collection of portraits of beggars and street traders, masterly studies of occupations and personalities.

For accurate recording of detail the etched line was well suited. How well can be seen in Edward William Cooke's *Shipping and Craft,* with its precisely observed studies of a variety of vessels. Equally notable are *Etchings Illustrative of Scottish Character and Scenery* by Walter Geikie (1795-1837); Geikie's achievement is the more remarkable as an illness left him both deaf and dumb from the age of two onwards. Another individualist is Charles Keene, well known as a *Punch* illustrator, whose unpretentious coastal scenes and figure studies have great quality. Others whose work is worth looking for include E. T. Daniell, a clergyman once taught by Crome, and James Smetham.

Etching was said to be 'an art peculiarly adapted for ladies' and the many books of instruction published in the early nineteenth century are proof of its appeal for amateurs. Some of the professionals, with the better – or more influential – amateurs, joined together in the Etching Club, founded in 1838. Among the members were the Academicians Thomas Creswick and C. W. Cope, but the club's greatest acquisition was Samuel Palmer, who joined in 1850. Palmer's great years as a painter were behind him; now he was to dedicate himself to perfecting a carefully wrought technique in etching through which images of poetic intensity emerged. In his chosen style, with plates heavily worked and frequently bitten, his achievement is unsurpassed; in his later works, 'The Bellman' and 'The Lonely Tower', he moves etching into regions penetrated by no other artist.

The members of the Etching Club, not excepting Palmer, had the common aim of producing plates as 'finished' as possible; for the most part their work has a literary flavour, telling a story – like so much of Victorian oil painting. About 1860 the so-called 'etching revival' began in France, making its effect in England

through the work of James McNeill Whistler, described by Arthur Hind in his study of the subject as 'the greatest personality in the history of modern etching'. Whistler's *Thames Set,* completed in 1871, is deservedly famous; in later years he developed his own wholly idiosyncratic style where much detail is omitted and the composition depends greatly on the areas of white paper and the pure etched line. Influenced by Whistler, together with his brother-in-law, Seymour Haden, and the solemn critical protagonist of the 'new movement', P. G. Hamerton, a band of dedicated professionals formed, recognised by the foundation of the Royal Society of Painter-Etchers and Engravers in 1880 and by the conferring of knighthoods on Haden and other leading figures. Prints by Muirhead Bone, David Cameron and Frank Short fetched enormous prices in the early decades of the twentieth century, enhanced by signatures and the limited number of impressions issued. Such prices are not commanded today; while the quality of the work is still obvious, the range of interest now seems restricted and the appeal limited. Perhaps the greatest of the painter-etchers to bridge the nineteenth and twentieth centuries is Walter Sickert, who brought a wider vision and richer artistic experience to enrich his technique.

It is not difficult to find attractive nineteenth-century etchings at reasonable prices. Do not worry about signatures or numbers or states; if it seems to be a good impression with no signs of wear, and you like the subject – then that is all that matters. Good examples are the studies of Cambridge by Robert Farren and the *Sketches of Eton* by R. S. Chattock; these views are both felt and observed, with nothing mechanical about them. Of all the printmaking media, etching provides the readiest contact between artist and observer.

11. Victoriana

Art on steel

Print publishers and professional painters were quick to see the opportunities provided by the discovery of the steel plate for engraving and an enormous number of prints of popular paintings flooded the market in the Victorian period. Line engraving or mixed mezzotint – mezzotint with line, etching or stipple – were the methods most used, and some of the print runs were very large; over fifty thousand impressions of Frith's 'Derby Day' were published. Among the many artists whose work was so widely publicised, and who profited thereby, were William Holman Hunt, Thomas Faed, Sir John Millais, Sir David Wilkie and, most notably of all, Sir Edwin Landseer. 'The Monarch of the Glen', engraved by Landseer's brother, Thomas, 'The Stag at

Bay', 'The Old Shepherd's Chief Mourner' and 'The Shepherd's Grave' dominated mid-Victorian parlours and, as Samuel Redgrave wrote, 'found a place in the affections of all'.

Sentimentalised children and melancholy maidens proliferate in these reproductive engravings, almost all of which are singularly lacking in vigour. Compare Frith's crowded scenes with those of Rowlandson or Hogarth, for example; in Sharpe's engraving of 'Life at the Sea-side', despite the closely observed detail the many characters seem to be frozen in poses ready to be framed and hung on walls. The sentimental and the static meet in many of the engravings of scenes from the Bible, although this is not so of W. H. Simmons's engraving of Holman Hunt's 'The Light of the World', deservedly one of the best known religious pictures of the century, nor of the plates by Charles Mottram after John Martin's 'The Great Day of His Wrath' or 'The Last Judgement'.

If they lack vigour, however, the Victorian engravings, especially those of the middle decades of the reign, are strong in earnestness. Perhaps it is because of this that they have become so scarce today; perhaps many of them were destroyed by members of a generation that had grown up under their admonitory gaze. Their survivors are not in much demand, although it is not impossible that one day they may become collectors' items.

The engravers themselves, who covered many acres of steel on subjects such as 'Sunday in the Backwoods of Canada' or 'The Bible: that is the Secret of England's Greatness', made little from their labours compared to the painters and printsellers. Thomas Landseer, George Thomas Doo and Edward Goodall were among the better of the line engravers, while Samuel Cousins excelled in mezzotint; his 'The Order of Release' after Millais is one of the finest prints of the period. The mixed mezzotint method, however, did not produce prints of much quality on the whole; it gives the impression that when the engraver came to something he found difficult to render he solved the problem by changing the technique. Towards the end of the century the Frenchman T. N. Chauvel etched some fine large plates after the landscapes of Benjamin Leader. By this time, however, photogravure was becoming the most popular reproductive process and comparatively few plates were being produced by the old methods.

Few British painters of the Victorian age interested themselves in printmaking of any sort, unlike their French contemporaries. Apart from Whistler, they virtually ignored the possibilities of lithography and they left the engraving of their pictures to others.

Baxter prints

George Baxter issued his colour prints between 1834 and 1860. The process, in which the outline of the design was imprinted from a steel plate with the colouring being applied by a number of

woodblocks, was patented in 1835 but was also used by other printers, notably Abraham Le Blond, to whom Baxter later sold the licence. Most of Baxter's work appeared in single plates, the subjects including topography, portraits, old master copies, story-telling pictures and contemporary scenes such as 'The Rev. J. Waterhouse superintending the landing of the Missionaries at Taranaki, New Zealand'. Most of the prints are quite small; they were commercially orientated productions but some collectors find them pleasing. No matter how one defines 'artistic merit' they cannot be claimed to have any, but they do exude a period flavour and, although unsubtle, are generally bright little objects. They are becoming expensive, however. Some of the plates issued by Le Blond are reissues of Baxter's. If you are interested in these prints it is worth consulting *George Baxter and the Baxter Prints* by Max E. Mitzman, published by David and Charles.

Transparencies, Transformations and Protean Views

Various print 'novelties' were published in the mid nineteenth century. The transparencies were fairly simple; a hand-coloured lithograph was mounted on a white backing sheet and parts of the lithograph were cut out, enabling light to shine through when the print was held up. This could give a three-dimensional effect, as with GW's transparency of the Thames Tunnel, where the cut-outs represented the gas lamps diminishing into the distance to a pinpoint – the end of the tunnel itself. The Thames Tunnel also featured as number 28 of Spooner's *Protean Views*, another hand-coloured lithograph. Held up to the light, this revealed the coronation procession of Queen Victoria from Buckingham Palace, printed on the reverse of the tunnel plate and backed with white tissue.

William Spooner also published a series of *Transformations*. One of these, number 12, is entitled 'The Union of the Flowers or the Royal Marriage'. In this the two subjects are thematically integrated; a print of flowers when held up to the light reveals the royal couple before a prelate. The backed-up designs blend with some success, the rose becoming part of Victoria's wedding gown and the crown imperial turning into a chandelier.

Prints of this type are extremely rare; they were fragile to begin with and by their nature were unsuitable for framing. You may be lucky and discover one in an unsorted miscellaneous portfolio.

12. Notes for collectors

Cleaning

Surface dust can be removed from a print with a very soft brush and general grubbiness may be treated with a soft eraser or a small

piece of moist bread. Prints can be washed in cold water, if handled carefully. For foxing or large stubborn stains a bleaching agent may be used, but it is advisable to consult an expert first. For obvious reasons, do not apply bleach to coloured prints.

When treating 'laid-down' prints – prints which have been stuck on to a cardboard backing – soak the item first and then remove the backing from the print (not the other way around). Warm or hot water may be needed, and a great deal of patience.

Framing

The choice of frame is a matter of taste but do not trim a print within the platemark in order to fit a frame. Do not use a wood backing in a frame. Never hang a coloured print where it may be exposed to direct sunlight. If sending a print to be framed, ensure that the framer does not lay it down.

Purchasing

Before you buy a print, examine it carefully. If possible, hold it up to the light to check for tears or repairs. If the print is framed and has obviously been in its frame for several years, ask if it can be removed for you to examine it properly. Take especial care when buying framed prints at auction. If in doubt, do not buy.

Storing

Prints are best stored in portfolios or in specially made storage cabinets. When storing prints be especially careful that there is no adhesive or sticky tape on the back. Keep them away from damp or excessive heat.

Collecting

It adds interest if at least some part of your collection has a common theme: railway lithographs, for example, or views of a particular county (over 3,500 prints of Devon have been listed) or place (seventy-nine prints of Tintern Abbey, at least). Or you can concentrate on individual artists or engravers. As far as the latter are concerned, the list that follows may be helpful.

Some leading engravers of the seventeenth, eighteenth and nineteenth centuries

Alken, H. (1785-1841): etcher, aquatint.
Alken, S. (1750-1815): aquatint.
Allen, J. B. (1803-76): engraver after J. M. W. Turner.
Allen, J. C. (*fl* 1831): engraver after J. M. W. Turner and Clarkson Stanfield.
Angus, W. (1752-1821): after Paul Sandby and Edward Dayes.
Armytage, J. C. (1820-97): re-engraved after Turner.
Bartolozzi, F. (1725-1815): stipple expert.

Basire, Isaac and three Jameses: four generations of engravers, Isaac born 1704 and the last James died 1869.

Bewick, T. (1753-1828): wood engraver.

Bluck, J. (early nineteenth century): aquatint.

Bourne, J. C. (1814-96): lithographer.

Boydell, John (1719-1804): engraver, publisher.

Boys, T. S. (1803-74): lithographer.

Brannon family: engravers, Isle of Wight, nineteenth century.

Buck, S. (1696-1779): engraver, Prospects and Views.

Buckler, J. C. (1770-1851): engraver, aquatint.

Byrne, W. (1743-1805): engraver.

Chesham, F. (1749-1806): etcher, aquatint.

Clenell, L. (1781-1840): wood engraver and painter.

Cooke, E. W. (1811-80): etcher, engraver and painter.

Cooke, G. (1781-1834): engraver, father of E. W.

Cooke, W. B. (1778-1853): engraver, with brother G.

Cooke, W. J. (1797-1865): engraver.

Cotman, J. S. (1782-1842): etcher and major painter of Norwich School.

Cousen, C. (1803-89): engraver.

Cousen, J. (1803-80): engraver.

Cousins, S. (1801-87): mezzotint engraver.

Dalziel family: nineteenth-century wood engravers.

Day, W. (1797-1845): lithographer, printer and publisher.

Dodd, R. (1748-c 1816): engraver and marine painter.

Doo, G. T. (1800-86): engraver.

Dutton, T. G. (*fl* 1850): lithographer.

Earlom, R. (1743-1822): mezzotint.

Faithorne, W. (c 1616-91): engraver.

Fielding, T. H. (1781-1851): engraver, aquatint, also painter.

Finden, E. F. (1791-1857): engraver.

Finden, W. (1787-1882): engraver.

Fisher, E. (c 1730-85): mezzotint engraver.

Fittler, J. (1758-1835): engraver, etcher.

Geikie, W. (1795-1837): etcher and painter.

Goodall, E. (1795-1870): engraver, etcher (after Turner).

Green, V. (1739-1813): mezzotint engraver.

Green, W. (1761-1823): aquatint, etcher (Lake District specialist).

Greig, J. (*fl* 1800-15): engraver.

Haghe, L. (1806-85): lithographer.

Harding, J. D. (1798-1863): etcher, engraver and lithographer.

Hassell, J. (1767-1825): aquatint, painter.

Havell, D. (*fl* 1812-26): aquatint.

Havell, R. (*fl* 1812-37): aquatint, brother of D.

Havell, W. (1782-1857): lithographer and painter.

Hawkins, B. W. (1810-52): lithographer.

Hawkins, G. (1809-52): lithographer (Menai Straits bridges).

Heath, C. (1785-1848): engraver.
Heath, J. (1757-1834): engraver, publisher, father of C.
Higham, T. (1796-1844): engraver (after Turner).
Hill, J. (1770-1850): aquatint.
Hogarth, W. (1697-1764): engraver, painter.
Hollar, W. (1607-77): etcher.
Horsburgh, J. (1791-1869): engraver (after Turner).
Hullmandel, C. J. (1789-1850): lithographer, publisher.
Hunt, C. (*fl* 1815): engraver.
Jeavons, T. (*c* 1800-67): engraver (after Turner).
Jukes, F. (1748-1812): aquatint.
Keene, C. S. (1823-91): etcher.
Kip, J. (1653-1722): etcher, engraver.
Landseer, T. (1795-1850): engraver, etcher.
Laporte, J. (1761-1839): engraver, etcher (soft-ground), aquatint.
Le Blon, J. C. (1667-1741): mezzotint colour printer.
Le Blond, A. (1819-94): engraver, colour printer after Baxter.
Le Keux, H. (1787-1868): engraver.
Le Keux, J. (1783-1846): engraver.
Le Keux, J. H. (1812-96): engraver, son of J.
Lewis, C. G. (1808-80): engraver, mezzotint.
Lewis, F. C. (1779-1856): etcher, aquatint, mezzotint engraver.
Lizars, W. H. (1788-1859): engraver, publisher.
Loggan, D. (1625-93): etcher, engraver.
Lowry, J. W. (1803-79): engraver.
Lowry, Wilson (1762-1824): engraver, father of J. W.
Lucas, D. (1801-81): mezzotint engraver after Constable.
Lupton, T. G. (1791-1873): engraver, mezzotint (after Turner).
MacArdell, J. (*c* 1729-65): mezzotint engraver.
Malton, J. (1761-1803): engraver, aquatint.
Malton, T. (1748-1804): aquatint.
Mazell, P. (*fl* 1760-95): engraver for Pennant's *Tours*.
Middiman, S. (1750-1831): engraver.
Miller, W. (1796-1882): engraver (after Turner).
Milton, T. (1743-1827): engraver.
Nicholson, F. (1753-1844): lithographer and painter.
Palmer, S. (1805-81): etcher, painter.
Pether, W. (*c* 1738-1821): mezzotint engraver.
Picken, T. (1815-70): lithographer.
Pickett, W. (*fl* 1805): aquatint.
Pollard, J. (1797-1867): engraver, aquatint and mezzotint.
Pollard, R. (1755-1838): engraver, aquatint.
Prestel, Marie (1747-94): aquatint.
Prout, S. (1783-1852): etcher, aquatint, lithographer and painter.
Pyall, H. (early nineteenth century): engraver, aquatint.
Pye, C. (1777-1864): engraver.
Pye, J. (*c* 1758-74): engraver.

Pye, J. (1782-1874): engraver (after Turner).
Pyne, W. H. (1769-1843): etcher and painter.
Radclyffe, E. (1809-63): engraver, etcher.
Radclyffe, W. (1780-1855): engraver (after Turner).
Reeve, R. G. (1803-89): aquatint.
Reeve, T. (*fl* 1820): aquatint.
Reynolds, S. W. (senior) (1773-1835): mezzotint engraver, etcher, aquatint.
Reynolds, S. W. (junior) (1794-1872): mezzotint engraver.
Rooker, M. (1743-1801): etcher, engraver.
Rosenberg, C. (*fl* early nineteenth century): aquatint.
Rowlandson, T. (1756-1827): etcher, painter.
Russell, J. (1745-1806): engraver.
Sandby, P. (1725-1809): etcher, aquatint, painter.
Say, W. (1768-1834): mezzotint engraver.
Shepherd, T. H. (1793-1864): aquatint, painter.
Smith, J. C. (1778-1816): engraver.
Smith, J. R. (1752-1812): mezzotint engraver.
Stadler, J. C. (died 1812): aquatint, mezzotint engraver.
Storer, J. (1781-1837): engraver.
Stothard, T. (1755-1834): etcher, engraver and painter.
Sutherland, T. (*c* 1785-1820): aquatint.
Tombleson, W. (*fl* 1820-40): engraver.
Tomkins, C. (1750-1823): etcher, aquatint.
Toms, W. H. (1712-50): engraver.
Turner, C. (1773-1857): mezzotint engraver, aquatint and stipple.
Vertue, G. (1684-1756): engraver, mezzotint engraver.
Vivares, F. (1709-80): engraver.
Vivares, T. (1735-1808): engraver, etcher (soft-ground).
Walker, J. (late eighteenth century): engraver, publisher.
Wallis, R. (1794-1878): engraver (after Turner).
Watts, W. (1752-1851): engraver.
Westall, W. (1781-1850): engraver, etcher (soft-ground), painter.
Willmore, W. T. (1800-63): engraver (after Turner).
Winkles family (early nineteenth century): engravers.
Woollett, W. (1735-85): engraver, etcher.
Young, J. (1755-1825): mezzotint engraver.

Some useful books

Abbey, J. R. *Scenery of Great Britain and Ireland in Aquatint and Lithography, 1770-1860.* London, 1953.
Abbey, J. R. *Life in England in Aquatint and Lithography, 1770-1860.* London, 1953.
Bewick, T. *Memoir of Thomas Bewick, Written by Himself.* London, 1862.
Booth, J. *Looking at Old Prints.* Westbury, 1983.
Buchanan, H. *Nature into Art.* London, 1979.

Calloway, S. *English Prints for the Collector*. London, 1980.
Chamberlain, W. *Engraving and Etching*. London, 1972.
George, M. Dorothy. *Hogarth to Cruikshank: Social Change in Graphic Satire*. London, 1967.
Dyson, A. *Pictures to Print*. London, 1984.
Gascoigne, B. *How to Identify Prints*. London, 1986.
Godfrey, R. T. *Printmaking in Britain*. Oxford, 1978.
Grant, M. H. *Dictionary of Etchers*. London, 1952.
Griffiths, A. *Prints and Printmaking*. London, 1980.
Guichard, K. M. *British Etchers*. London, 1977.
Hardie, M. *English Coloured Books*. London, 1906.
Hayden, A. *Chats on Old Prints*. London, 1900.
Hind, A.M. *A History of Engraving and Etching*. London, 1908.
Hind, A.M. *An Introduction to a History of Woodcut*. London, 1935.
Holloway, M. *A Bibliography of Nineteenth Century British Topographical Books with Steel Engravings*. London, 1977.
Hughes, T. *Prints for the Collector*. London, 1970.
Hunnisett, B. *Steel-engraved Book Illustration in England*. London, 1980.
Ivins, W. *Prints and Visual Communication*. Cambridge, Massachusetts, 1953.
Klingender, F. G. *Art and the Industrial Revolution*. London, 1968.
Mayor, A. Hyatt. *Prints and People*. Princeton, New Jersey, 1971.
Prideaux, S. T. *Aquatint Engraving*. London, 1909.
Rawlinson, W. *The Engraved Work of J. M. W. Turner*. London, 1908.
Redgrave, R. *Dictionary of Artists of the English School*. London, 1878.
Rees, G. *Early Railway Prints*. Oxford, 1980.
Russell, R. *Guide to British Topographical Prints*. Newton Abbot, 1979.
Somers Cocks, J. V. *Devonshire Topographical Prints*. Exeter, 1977.
Tooley, R. V. *English Books with Coloured Plates*. London, 1954.
Twyman, M. *Lithography 1800-1850. The techniques of drawing on stone in England and France and their application in works of topography*. London, 1970.
Vaughan, J. *The English Guide Book*. Newton Abbot, 1974.
Whitman, A. *The Print Collector's Handbook*. Reprinted Wakefield, 1973.
Wilder, F. L. *English Sporting Prints*. London, 1974.

Some dealers in prints

The largest collection of prints is in the Print Room of the British Library. Most major libraries have print collections, as do county reference libraries and the local collections of public libraries.

There are print dealers in most large towns and many antiquarian booksellers and antique dealers also sell prints. Specialist print sales are held from time to time at the London auction houses and prints are often to be found at auction sales throughout Britain.

A list of the names and addresses of print dealers follows. Please note that it is not comprehensive.

Arthur Ackerman and Son Limited, 3 Old Bond Street, W1X 3TD. Telephone: 01-493 3288.

Barnard Gallery, Grange Farm, Everton (Notts), near Doncaster, South Yorkshire DN10 5BG. Telephone: Retford (0777) 817324.

Baynton-Williams, Maltravers House, 49 Maltravers Street, Arundel, West Sussex BN18 9BQ. Telephone: Arundel (0903) 882898.

Burlington Gallery Limited, 10 Burlington Gardens, London W1X 1LG. Telephone 01-734 9228.

D. M. Beach, 52 High Street, Salisbury, Wiltshire SP1 2PG. Telephone: Salisbury (0722) 333801.

Benet Gallery, 19 King's Parade, Cambridge CB2 1SP. Telephone: Cambridge (0223) 353783.

Brobury House Gallery, Brobury, Herefordshire HR3 6BS. Telephone: Moccas (098 17) 229.

Cartographia, Pied Bull Yard, Bury Place, London WC2 E7E. Telephone: 01-404 4050.

Channel Islands Galleries, Trinity Square, St Peter Port, Guernsey. Telephone: Guernsey (0481) 23247.

Hilary Chapman, 821 Fulham Road, London SW6. Telephone: 01-731 5888.

Collectors Treasures, Harrods Old Maps and Prints, 4th Floor, Harrods, London SW1. Telephone: 01-730 1234 extension 2124.

Collectors Treasures, 4 Liston Court, Marlow, Buckinghamshire SL7 1ER. Telephone: Marlow (062 84) 73424.

P. and D. Colnaghi and Company Limited, 14 Old Bond Street, London W1X 4JL. Telephone: 01-491 7408.

The Corner Shop, 5 St John's Place, Hay-on-Wye, Hereford. Telephone: Hay-on-Wye (0497) 820045.

Cottage Gallery, Croxton Green, Cholmondeley, Cheshire. Telephone: Cholmondeley (082 922) 371.

Michael and Verna Cox, 139 Norwich Road, Wymondham, Norfolk NR18 0SJ. Telephone: Wymondham (0953) 605948. (By appointment only.)

Robert Douwma Prints and Maps Limited, 4 Henrietta Street, The Piazza, Covent Garden, London WC2E 8QU. Telephone 01-836 0771.

Andrew Edmunds, 44 Lexington Street, London W1R 3LH. Telephone: 01-439 8066.

Francis Edwards, Cranborne House, The Pavement, Hay-on-Wye, Hereford HR3 5DF. Telephone Hay-on-Wye (0497) 820148.

D. G. and A. S. Evans (Books, Maps, Prints) 7 The Struet, Brecon LD3 7LL. Telephone: Brecon (0874) 2714.

Oriel Evans, Exeter House, King Street, Laugharne, Dyfed SA33 4RY. Telephone: Laugharne (099 421) 635.

W. G. Evans, Historic Prints and Maps, 83 Llanthewy Road, Newport, Gwent NP9 4JZ. Telephone: Newport (0633) 841852.

Focus Fine Arts Limited, 25 Devonshire Street, London W1N 1RJ. Telephone: 01-935 0530.

Fores Gallery Limited, Potterspury House, Potterspury, Towcester, Northamptonshire NN12 7QL. Telephone: Yardley Gobion (0908) 543289.

Gallery Imprint, 71 Main Street, Addingham, Ilkley, West Yorkshire.

Garton and Co, 39-42 New Bond Street, London W1Y 9HB. Telephone: 01-493 2820.

Grosvenor Prints, 28/32 Shelton Street, Covent Garden, London WC2. Telephone: 01-836 1979.

Harlequin Gallery, 22 Steep Hill, Lincoln, Lincolnshire. Telephone: Lincoln (0522) 2258.

Harrington Brothers, The Chelsea Antique Market, 235 Kings Road, Chelsea, London SW3 5EL. Telephone: 01-352 5689.

R. P. Hepner, Lion Gallery and Bookshop, 15A Minshull Street, Knutsford, Cheshire. Telephone: Knutsford (0565) 52915.

Julia Holmes, Muirfield Place, Haslemere, Surrey GU27 1AE. Telephone: Haslemere (0428) 2153. (By appointment only.)

J. Alun Hulme, 54 Lower Bridge Street, Chester, Cheshire CH1 1RU. Telephone: Chester (0244) 44006 or 336472.

Ingol Maps and Prints, Cantsfield House, 206 Tag Lane, Ingol, Preston, Lancashire PR2 3TX. Telephone: Preston (0772) 724769. (Postal business only).

Jasper Fine Arts, 67 Victoria Street, Windsor, Berkshire SL4 1EM. Telephone: Windsor (0753) 854925.

King's Court Galleries, 54 West Street, Dorking, Surrey RH4 1BS. Telephone: Dorking (0306) 881757.

Lantern Gallery, 9 George Street, Bath, Avon BA1 2EH. Telephone: Bath (0225) 63727.
Michael Lewis Gallery, 17 High Street, Bruton, Somerset BA10 0AB. Telephone: Bruton (0749) 813557.
Magna Gallery, 41 High Street, Oxford OX1 4AP. Telephone: Oxford (0865) 245805.
The Map House, 54 Beauchamp Place, Knightsbridge, London SW3 1NY. Telephone: 01-589 9821/4325.
G. and D. I. Marrin and Sons, 149 Sandgate Road, Folkestone, Kent CT20 2DA. Telephone: Folkestone (0303) 53016.
Moore, 24-5 Bridge Street, Hitchin, Hertfordshire SG5 2DF. Telephone: Hitchin (0462) 50497.
John Nelson, 22-4 Victoria Street, Edinburgh EH1 2JW. Telephone: 031-225 4413.
Richard Nicholson of Chester, 25 Watergate Street, Chester, Cheshire CH1 2LB. Telephone: Chester (0244) 326818.
Avril Noble, 2 Southampton Street, Covent Garden, London WC2E 7HA. Telephone: 01-240 1970.
Oldfield, 34 Northam Road, Southampton, Hampshire SO2 0PA. Telephone: Southampton (0703) 638916.
O'Shea Gallery, 89 Lower Sloane Street, London SW1W 8DA. Telephone: 01-730 0081 or 0082.
Roy Ostle, Ogwen Antiques, 10 High Street, Bethesda, Gwynedd LL57 3AG. Telephone: Bethesda (0248) 600549.
Jean Pain Galleries, 7 Kings Parade, Cambridge CB2 1SJ. Telephone: Cambridge (0223) 313970.
The Petersfield Bookshop, Chapel Street, Petersfield, Hampshire GU32 3DS. Telephone: Petersfield (0730) 63438.
Pierpoint Gallery, 10 Church Street, Hereford HR1 2LR. Telephone: Hereford (0432) 267002.
Rex Poland Gallery, 25 South End, Croydon, Surrey CR0 1BE. Telephone: 01-680 5311.
Jonathan Potter Limited, 21 Grosvenor Street, London W1X 9FE. Telephone: 01-491 3520.
Printed Page, 2/3 Bridge Street, Winchester, Hampshire SO23 9BH. Telephone: Winchester (0962) 54072.
Quinto, 34 Trinity Street, Cambridge CB2 1TB. Telephone: Cambridge (0223) 358279.
Reigate Galleries Limited, 45a Bell Street, Reigate, Surrey RH2 7AQ. Telephone: Reigate (0737) 246055.
John Roberts Bookshop, 43 Triangle West, Clifton, Bristol, Avon BS8 1ES. Telephone: Bristol (0272) 268568.
C. Samuels and Sons Limited, 17-18 Waterbeer Street, Guildhall Shopping Centre, Exeter, Devon EX4 3EH. Telephone: Exeter (0392) 73219.
Sanders of Oxford Limited, 104 High Street, Oxford OX1 4BW. Telephone: Oxford (0865) 242590.
Scotia Maps, 173 Canongate, The Royal Mile, Edinburgh EH8 8BN. Telephone: 031-556 4710.
John Shotton, 89 Elvet Bridge, Durham City DH1 3AG. Telephone: Durham (0385) 64597.
Henry Sotheran Limited, 2-5 Sackville Street, London W1X 2DP. Telephone: 01-734 1150 or 0308.
Stable Antiques, 14 Loughborough Road, Hoton, Loughborough, Leicestershire LE12 5SF. Telephone: Wymeswold (0509) 880208.
Tooley Adams and Company Limited, 83 Marylebone High Street, London W1M 4AL. Telephone: 01-486 9052, 01-935 5855. Fax: 01-224 2230.
Towcester Print Shop, 118 Watling Street East, Towcester, Northamptonshire. Telephone: Towcester (0327) 51278.
The Tudor Rose Antiques, 31 and 32 Castle Street, Beaumaris, Anglesey, Gwynedd LL57 8EE. Telephone: Beaumaris (0248) 810203.
Robert Vaughan, 20 Chapel Street, Stratford-upon-Avon, Warwickshire CV37 6EP. Telephone: Stratford-upon-Avon (0789) 205312.
Warwick Leadlay Gallery, 5 Nelson Road, Greenwich, London SE10 9JB. Telephone: 01-858 0317.
Welbeck Gallery, 18 Thayer Street, London W1M 5LD. Telephone: 01-935 4825.
West Gate Fine Art, 16 Peter's Street, Canterbury, Kent CT1 2BQ. Telephone: Canterbury (0227) 453636.
William Weston Gallery, 7 Royal Arcade, Albemarle Street, London W1X 3HD. Telephone: 01-493 0722.
The Witch Ball, 48 Meeting House Lane, Brighton, East Sussex BN1 1HB. Telephone: Brighton (0273) 26618.
E. Whiteson, 66 Belmont Avenue, Cockfosters, Hertfordshire EN4 9LA. Telephone: 01-449 8860.
Zwan Antiques, Timberscombe, Minehead, Somerset TA24 7TG. Telephone: Timberscombe (064 384) 608.

Index